THE
1937
CHICAGO
STEEL STRIKE

THE
1937
CHICAGO
STEEL STRIKE

BLOOD ON THE PRAIRIE

JOHN F. HOGAN

Charleston London

THE
History
PRESS

Published by The History Press
Charleston, SC 29403
www.historypress.net

Copyright © 2014 by John F. Hogan
All rights reserved

Front cover: Steelworkers Organization of Active Retirees.
Back cover, top left: Steelworkers Organization of Active Retirees; *top right*: Illinois Labor
History Society; *bottom*: Steelworkers Organization of Active Retirees.

First published 2014

Manufactured in the United States

ISBN 978.1.62619.343.7

Library of Congress CIP data applied for.

For our grandchildren, Sam C., Matthew, Keelin, Seamus and Sam H.

CONTENTS

PREFACE

A lthough I come from a police family and worked a summer break from college on the open-hearth furnaces at Republic Steel's South Chicago plant, I don't remember anyone in either setting mentioning the tragic 1937 Memorial Day encounter. I became only vaguely aware of the fatal episode sometime later, probably from reading cryptic flashbacks in the newspapers. Even today, when I mention the event to informed longtime Chicagoans, I often find that I'm telling them something they're hearing for the first time. Chicago Fire Department historian John Rice has suggested that tragic events such as the Iroquois Theater fire or the capsizing of the SS *Eastland* become part of a collective amnesia because people don't want to remember something so horrible.

The Memorial Day incident—or massacre, as many call it—was horrible; it never should have happened. The eight minutes of newsreel footage recorded that day depict a "police riot," to borrow a term from the presidential commission that investigated the disturbances at the 1968 Democratic convention in Chicago. What happened on May 30, 1937, far exceeded anything that transpired thirty-one years later. The police shot forty people, ten fatally. All but four were hit from the back or side. Dozens were clubbed as they fled a tear gas barrage, some as they lay defenseless.

Steelworkers Local 1033 has conducted periodic memorial gatherings to keep the memory fresh. A sculpture dedicated to those killed stands a half block north of the union hall on the city's Southeast Side, the building itself dedicated to the dead of 1937. Like the Iroquois, the *Eastland* or the Stock

Preface

Yards Fire of 1910, this is a chapter of Chicago history that deserves to be preserved. This account is not intended to be pro or anti union, industry, police or government—local, state or federal. What follows, I hope, is a straightforward presentation of the facts in an attempt to capture a seminal period of labor history and, more specifically, the tragic event that marked its nadir. The heroes, rogues and those between, on all sides, identify themselves through their own words and actions.

Like most everything I've attempted to write, this project would not have reached final form without the invaluable help of my editor-in-chief—and spouse—Judy Ellen Brady, who took time away from writing her own book to keep me on course.

Friend, neighbor and professional editor Andrea Swank, who is always there when my work requires doctoring, acquitted herself with distinction once again.

Alex Burkholder, my collaborator on *Fire Strikes the Chicago Stock Yards*, shared his extensive knowledge of Chicago history while also providing encouragement and a big assist with the graphics.

The last president of Local 1033, United Steelworkers of America (USWA), Victor Storino, was most generous with his time and access to the union's files. Victor and his brothers and sisters in the Steelworkers Organization of Active Retirees (SOAR), as feisty and likable a bunch of seniors as anyone would care to meet, made me feel welcome from the outset.

The research staffs at three of my "offices," the Chicago History Museum (CHM), Newberry Library and the Municipal Reference division of the Chicago Public Library (CPL), were unfailingly helpful and friendly, as always, even when confronted with dumb questions. A fourth "office," the John Merlo Branch of the CPL, offered a quiet retreat for writing, particularly on winter days with snow covering the front lawn of the church rectory next door, seen through the Merlo's west windows.

Elizabeth Murray Clemens of the Walter P. Reuther Library at Wayne State University in Detroit and Emily K. Harris of the United Mine Workers Union (UMW) in Washington, D.C., graciously responded to requests for photographic material. The Illinois Labor History Society in Chicago also provided help with visuals.

When I called Adriana Schroeder, the historian of the Illinois National Guard in Springfield, she found herself inundated with requests for information regarding the 150th anniversary of the Battle of Gettysburg. Nonetheless, she allotted all the time I needed for background on the National Guard's part in the Republic strike. Doing so, she handed this old

reporter a small scoop—the long-confidential identity of the undercover National Guard officer who provided the governor with intelligence before, during and after the Memorial Day encounter.

Family friend and research librarian Carla Owens answered an urgent eleventh-hour call to help finish the project. Judy and I still owe you and Matthew that dinner, Carla.

Visit us at
www.historypress.net
...

This title is also available as an e-book

CHAPTER 1
GODFATHERS

The rural Midwest in the last quarter of the nineteenth century hardly could have produced two more philosophically dissimilar national figures. Born three years apart, Tom (Tom, not Thomas) Mercer Girdler and John Lewellen Lewis now seem as though they were preordained to follow a collision course as the interaction of labor and capital became revolutionized, often with tragic results. Girdler and Lewis personified the immovable object and the irresistible force. They bestrode the American stage, alternately cajoling and defying federal and state bureaucrats, Congress and even presidents in pursuit of their diametrically opposed visions.

By the late 1930s, the pipe-smoking Girdler, chairman of Republic Steel Corporation and president of the American Iron and Steel Institute, and United Mine Workers chief and CIO founder Lewis, who favored cigars, together commanded hundreds of thousands of blue-collar workers with a stake on both sides of the divide. Lewis, with his massive head, leonine mane, perpetually glowering visage and, above all, eyebrows sufficiently overgrown to accommodate three faces, was by far the most visible and well known. (The *Chicago Tribune*, no fan of organized labor or its leaders, delighted in describing Lewis as "beetle-browed." He was a cartoonist's godsend.) In the '30s and '40s, his image loomed almost as prominently in newspapers and movie newsreels as that of President Roosevelt, whose jutting chin and jaunty cigarette holder also were no strangers to caricature. Tom Girdler, on the other hand, would fail to stand out in any CEO group portrait, a very ordinary-looking man who wore round, dark-rimmed glasses perched

below an expanse of full-frontal baldness. Yet the bland exterior masked an extraordinary individual, just as hard-nosed as Lewis, though unlike his adversary, "Tough Tom," as he was called, was known to smile occasionally.

Community organizer and Lewis biographer Saul Alinsky sneered that Girdler was tough—if profanity and table-pounding constituted attributes of toughness. If Alinsky had read Girdler's autobiography, he came across an episode the steel man related about his time as a young foreman at the Oliver Iron & Steel Company of Pittsburgh. When he challenged a subordinate "three inches (taller) and forty pounds heavier" for leaving early, Girdler wrote, the man not only refused to return to his machine but cursed him as well. "There was never a day in my life when I wouldn't fight when anyone called me that." Tough Tom said he punched the worker in the mouth, and the ensuing fight continued until he wrestled the bigger man down, hammered his head on the brick floor and didn't stop until his opponent lay unconscious. The subordinate didn't suffer any lasting injuries but never returned to the plant. Girdler said his own supervisor shrugged off the incident.

Girdler was born on a farm near Sellersburg, Indiana, about eight miles due north of Louisville, Kentucky, the third of five children. He and all his siblings were delivered by their maternal grandfather, a familiar and well-regarded doctor who traveled the territory by horse and buggy. In addition to the family farm, the Girdlers owned and operated a nearby cement factory, the brainchild of a wealthy uncle who brought his brother-in-law, Tom's father, on board. By Girdler's account, the farm and cement factory did well enough for the family to retain a "hired girl" and enable them to send their two daughters to private school in Louisville. Nevertheless, he suggested that his father may have lacked the funds to send him to college, and that was the primary reason he ended up teaching after graduation from high school. At nineteen, when others his age had at least one year of college behind them, circumstances changed. Aunt Jenny, wife of the cement factory founder, decided it was time for her nephew to begin his higher education. She dipped into the childless couple's fortune and told Tom he was going to Harvard. Girdler balked. He'd been hoping for such an offer from "dictatorial Aunt Jenny" but was determined to pursue a mechanical engineering degree. Tough Tom hung tough; he enrolled at Lehigh University in Bethlehem, Pennsylvania, with Aunt Jenny's blessing (and cash).

The story of the Girdlers is not one of a family who disembarked at Ellis Island. Nor is it one of the countless families of tenant farmers who populated the nineteenth-century countryside. Yet the title of Tom Girdler's

autobiography, published in 1943, more than twenty years before his death, suggests otherwise. A browser, plucking a copy of *Boot Straps* off a bookshelf, might expect to read about a Horatio Alger–type character who sheds his rags for riches, not about the grandson of a doctor, the son and nephew of factory owners who turned down an opportunity to attend Harvard in favor of another university. Girdler spent years crafting the image of the self-made man and succeeded, if a 1937 newspaper profile is any indicator. "Tom Girdler is no golden spoon aristocrat. His father was a farmer and his grandfather a country doctor…He earned his first money—fifty cents a day—by pulling weeds."

Young Tom did indeed work on the family farm, long and hard, according to his telling, just as he worked at the cement factory during summers off from Lehigh. The family may not have been "aristocrats" in the strictest sense, but in *Boot Straps*, Girdler described a lineage that he seemed to believe was first among equals. The Girdlers helped build the United States of America, he boasted, and by implication he wasn't about to watch John L. Lewis, the CIO and their Communist pals tear it down. The nation-building process, he explained, was typified by his "resolute, God-fearing [paternal] grandfather [and] his sea voyages…All the Girdlers had been seafaring men, ship captains," including his great-grandfather, "who went to sea against the British in 1780 when he was fourteen." A great-uncle also fought in the American Revolution, while the great-grandfather returned to duty as a navy captain during the War of 1812. All the Girdler men fought in the Civil War. While he made no mention of his mother's family's military service, he stated that the earliest of them to come to America landed in Massachusetts in 1635, only fifteen years after the Pilgrims set foot on Plymouth Rock. "So, good or bad," Tough Tom concluded, "every fiber of me is American."

Girdler had always wanted to work in the steel industry. After graduation from Lehigh in 1901, he began to fulfill his dream, dashing the family's expectations that he would return to the cement company and eventually take over the business. Off to London he went, to work in the recently opened office of the Buffalo Forge Company as a salesman of heating and ventilating equipment. He remained there less than a year, "living in a shabby, one-bedroom boarding house." In another deviation from the bootstrap image, he came back to the United States at the behest of a classmate and fraternity brother, the scion of a wealthy, socially prominent Pittsburgh family who owned Oliver Iron & Steel. The friend arranged for Girdler to join the ranks of three thousand employees at the oldest establishment of its kind in the

Pittsburgh area. One of the classmate's uncles could claim an estate valued at $16 million; another was a United States senator.

The new arrival began his career as foreman of the bolt shop where he was to have the knockdown fight with the subordinate. He saw himself as an anomaly because of his college education. Some bosses in the plant, he said, "preferred to believe that the only way to make yourself useful in the steel business was to start with a wheelbarrow or shovel." (Bootstraps, anyone?) Been there, done that, he seemed to believe, while realizing that he was bucking "a real prejudice...against education." The following year found him moving up to superintendent of the nut factory, which employed "150 men and 75 girls," the latter giving him "75 times as much trouble as all the men."

Girdler left the Oliver Company in 1905 and rose through the ranks at several steel companies, including Jones & Laughlin, which he joined in 1914. He became that company's president in 1928, and the following year, he combined with Cleveland industrialist Cyrus Eaton and other steel executives to forge Republic Steel Corporation from a cross section of smaller operations, among them a pipe manufacturer, a nut and bolt business and a blast furnace concern. "Some of what we had was good. A little was excellent. But most was junk," he said. Creation of the new corporation virtually coincided with the start of the Great Depression. Girdler compared himself to Robinson Crusoe, "that castaway [who] took out of a wrecked ship the stores and tools with which to attempt survival on an island amid fierce conditions." Becoming chairman of Republic in 1930, he launched it on a path to become the nation's number three steel producer.

Long before Girdler took over the helm at Republic, the principle of collective bargaining had been making significant progress in the steel industry. "I am not against unions," Tough Tom asserted in his autobiography. "I have never been against unions," only some union leaders. Others would vehemently disagree. Where Girdler saw himself as "fair but firm," unionists saw a slave driver, a fighter with no regard for human feelings. "There is no place in business for laziness, ignorance and inefficiency," he declared in 1937. "The workman who does his work well is entitled to a wage rate which will give him a decent standard of living." Fair enough, but his disdain for the lazy, ignorant and inefficient hinted at a belief in social Darwinism. "Much of the squalor is made by those who live in it. With free water and cheap soap, who other than poorly trained children really is obliged to live in filth...My mother often scrubbed to keep our house clean, and when she did I often had to carry water from the pump."

Not surprisingly, as the country struggled to pull out of the Depression, Tom Girdler and his labor antagonists viewed industrial America through two very different sets of spectacles. Since his first days in the workforce, Girdler saw fantastic gains. "Wages have increased at least seven or eightfold," and working conditions improved each year. The eight-hour day was difficult to implement, he conceded, because of the nature of steelmaking. "You can't put out the blast furnace fire each night; therefore you have continuous operation."

Neither Republic nor U.S. Steel, the industry Goliath, ever interfered with their employees' right to join a union as long as other employees retained the right to opt out, which the large majority did. Such an arrangement, of course, crippled the workers' ability to exert any real bargaining leverage, which was fine with the companies. The controversy over the "open shop" versus the "closed shop"—everyone must belong, no one "rides free"—became the most irreconcilable issue standing in the way of labor peace. Republic offered its people membership in something called the Employees Representation Plan (ERP). Girdler bristled at suggestions that the group amounted to a company union. The organization was run by workers chosen by their peers in secret balloting conducted at the plants, he stressed. The company insisted that it kept hands off, but militants scoffed that the representatives were nothing but toadies, easily swayed by management. The purpose of the ERP was to prevent a real union from coming in, some workers believed, claiming that foremen persuaded their underlings to join by offering them special privileges. Instead of improving, wages, safety and working conditions became worse, they added. Nonetheless, Girdler declared, "Among the half-million people employed in the steel industry nowhere was there a better satisfied lot than men on the payrolls of Republic Steel Corporation at the beginning of 1937."

Leaders of the newly formed Committee (later Congress) of Industrial Organizations (CIO) believed that such workers were either liars or fools in need of some serious re-education. Take-home pay at that time averaged about $400 a year. Employees worked without contracts. Management could turn away a worker at the plant gate on any day for any reason. Republic developed an elaborate system of espionage and blacklists that made organizing nearly impossible, the United Steelworkers of America (USWA) maintained. Veteran Chicago-area union leader Ed Sadlowski added, "[Steelworkers] were tired of being forced to work ten or twelve-hour days. A seven-day week with no overtime provisions. No vacations, no holidays, no insurance, no pensions, no grievance procedures, no safety

and sub-standard wages." Such were the issues that drove the steel industry organizing movement as labor and management headed into the watershed year 1937.

While Tom Girdler's forbearers were "helping to build the United States," those who preceded John L. Lewis were digging "black diamonds" from the coal fields of Wales to power the Industrial Revolution in Great Britain. Novelist Thomas Wolfe wondered at the strange destiny that led the English to the Dutch (in seventeenth-century America). So, too, he might have puzzled about the fate that led Lewis's grandfather and father from their native land, not to the mining areas of Ohio or Pennsylvania that lured most of their countrymen but to the hill country of Lucas County, Iowa, just north of the Missouri state line. It was here where coal was discovered in 1876, about the time John Watkins and Tom Lewis arrived to work the new Whitebreast Mine. "It was a common practice among mine owners," Lewis biographers Melvyn Dubofsky and Warren Van Tine pointed out, "to recruit

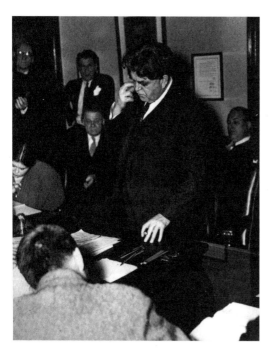

experienced British miners through extensive advertising in immigrant newspapers and labor journals."

Most associate Iowa with farming, but from the time of John L. Lewis's birth in 1880 until approximately the years of World War I, coal miners were almost as numerous as farmers in an area extending fifty miles south and east of Des Moines, according to *John L. Lewis: A Biography*. A substantial number of miners were Welsh. In fact, Tom Lewis had not become an American citizen by 1900; John's grandmother admitted to being illiterate in English.

CIO co-founder and longtime United Mine Workers (UMW) chief John L. Lewis made the organizing of steelworkers one of his highest priorities. *Courtesy of the Walter P. Reuther Library, Wayne State University.*

Anyone examining the life of John L. Lewis is faced with the challenge of separating myth from reality almost from

the beginning. That Tom Lewis worked long hours at the Whitebreast Mine and became a leader of the local Knights of Labor is not in dispute. What is far from certain is his role during a bitter strike at the mine in 1882—or whether, in fact, there even was a strike. Family lore portrayed Tom as a die-hard leader of a protracted walkout who ended up on a blacklist. Dubofsky and Van Tine wrote that they were unable to find any reference to a coal strike at that time or place in state, federal, union or newspaper records.

The period 1882 to 1897 saw the family continually on the move to towns and cities of central and southern Iowa, leaving scarcely a footprint. Along the way, five brothers and sisters joined firstborn John, whose life between the ages of three and seventeen "seems almost a closed book," according to the biographers. Loquacious Tom Girdler loved to tell stories and left an autobiography. The few, sometimes suspect, references that Lewis made to his early life had to be pried out of him by journalists or Alinsky, the lone biographer in whom he confided. "The most ordinary aspects of his early life remain forever hidden," concluded Dubofsky and Van Tine.

Lewis opened up a bit to Alinsky for the latter's 1949 biography. The union boss revealed that he left school after eighth grade and "was eager to settle arguments with the fist," perhaps a harbinger of the bellowing, intimidating style that the outsize Lewis would pursue as an adult. The missing chapters include the years 1901 to 1905, when the young man headed west to knock around the mine fields of the Rockies. Here the word "verified" takes on special importance as three alleged exploits are considered. The first concerns an incident in a mine shaft where Lewis was confronted by a mean-spirited mule determined that the miner before him would never see daylight again. The powerfully built young man supposedly cold-cocked the animal with a right cross and then bludgeoned him to death with a timber. Another adventure had him swimming the raging waters of the Big Horn River in Wyoming during flood season. Finally, Lewis was reputed to have helped carry out the bodies of thirty-six coal miners killed in the 1905 Union Pacific Mine disaster at Hannah, Wyoming.

Fact, fiction or something in between, the episodes preceded Lewis's return to Lucas, Iowa, in 1906. He went back to work in the coal mines but soon tried his hand at several businesses, as well as local politics, finding time to get married as he sought his calling. In 1908, having failed as a businessman and politician, he and his wife continued the family tradition of pulling up stakes. Historians have wondered not necessarily why John and Myrta left Lucas but why they chose to settle in Panama, Illinois, of all places, a newly

formed company town located in the cornfields of West Central Illinois, some forty miles south of the state capital of Springfield.

The Lewis family's move to Illinois, followed by John's election as president of UMWA Local 1475, underscores a theme that runs through the Dubofsky–Van Tine biography: while John was obviously dedicated to advancing the well-being of working people, his overriding goal was to better his own lot and that of his family. "A fondness for worldly goods and social climbing characterized much of Lewis's personal behavior," we are told. "Paradoxically, however, without the collective strength and solidarity of common folk, Lewis could never have satisfied his more personal, selfish ambitions." He began to dress in finely tailored, conservative business suits, drove Cadillacs and maintained three homes in Springfield that Myrta filled with expensive furniture and china. John joined prestigious country clubs, saw his name in the society pages, put family members on the union payroll and became president of a bank in Indianapolis. Except for a flirtation with President Roosevelt in the mid-1930s, he was a Republican for most of his life, a backer of Harding, Coolidge, Hoover and Wilkie, not out of political principle but simply because the GOP occupied the seat of power in the 1920s and early '30s while Roosevelt had incurred his wrath in 1940. Lewis alternately railed against Communists but welcomed their help to suit his needs of the moment. At a 1923 UMW convention, Lewis, at the podium, denounced Communists seated in the gallery as "industrial buzzards" and ordered them back to their "beloved Russia." Years later, when questioned about Communists working for the CIO, he declared that he didn't turn people upside down to see what kind of literature fell out of their pockets.

After leaving Panama, Lewis immersed himself in the always-tumultuous affairs of the UMW. He caught the eye of the venerable Samuel Gompers, veteran leader of the American Federation of Labor (AFL), who hired him as an organizer. During his tenure, Lewis remained involved with the UMW, left the AFL in 1917 and became acting president of the miners' union two years later. That same year, 1919, saw him take the miners out on strike in defiance of President Wilson, Congress, American public opinion and a court injunction. Everyone except John L. Lewis and his coal miners considered the strike a national emergency. Forty days later, under intense pressure from Wilson, Lewis called off the strike, saying, "I will not fight my government, the greatest government on earth." The UMW boss barely salvaged enough of a deal to convince the still-restive rank and file to go along. Thirty-nine-year-old John L. Lewis may have been the most unpopular man in the country, but everyone understood he was someone to reckon with.

Lewis capped the 1919 strike by winning election to an official term as UMW president in 1920. He personally selected Philip Murray, a studious, diligent UMW official, as his vice-president, beginning an odd-couple relationship that would begin to shatter nearly two decades later when Murray unilaterally launched the disastrous strike that led to ten deaths in Chicago. For now, though, Lewis was feeling full of himself. He challenged his mentor, Gompers, for the AFL leadership in 1921 but lost. The

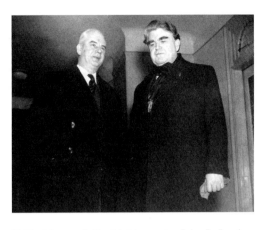

Philip Murray (left) with his mentor John L. Lewis, served as Lewis's second-in-command at the UMW and CIO before assuming leadership of the steelworkers' union in 1936. *Courtesy of the United Mine Workers of America Archive.*

next year, he took the miners out on strike again and this time won a then-respectable daily wage of $7.50, "but he could not force [the mine operators] to give regular daily work to his miners," Alinsky added. Nonunion mines, which paid an average $3.00 a day, were producing nearly two-thirds of the national output. The coal mining industry in the 1920s became the metaphorical canary in the coal mine relative to the overall U.S. economy. When the national Depression finally arrived, all that Lewis, his miners and the coal operators could say was, "Welcome to hard times."

Naturally, conditions for the mining industry only grew worse. "With rising unemployment and a shrinking consumer market, railroad traffic diminished, steel mills cut production and utility companies transmitted less power," Dubofsky and Van Tine stated. The times spelled disaster for coal miners and their families, who faced "hunger, mental depression [and] stark poverty." Instead of retrenching, however, Lewis confided to Alinsky, it was time to attack and "organize the unorganized," starting with the steel industry. Whenever he sat down to negotiate a contract, the UMW chief said, the coal operators would try to justify an unreasonable position by pointing out that the steelworkers were paid less and thus the miners should be satisfied. "It became increasingly clear that the mineworkers could never really win a just wage until the steelworkers were organized and their own miserable wages raised to a human, decent standard." This "simple, elementary, economic fact," Lewis argued, applied not only to

miners but also to other organized union groups. Beginning with steel, Lewis planned to embark on a grand strategy to bring the workers of all unskilled industries—auto, rubber, aluminum, other assembly line operations—under the umbrella of one labor organization. He fully realized that such a move would place him at loggerheads with the AFL and its skilled craft unions—the carpenters, the plumbers, the electricians, to name a few. Since the earliest days of Sam Gompers, these union members had looked askance at their unskilled brothers and sisters and repeatedly denied them full membership in their club. One international president branded mass production workers "the rubbish at labor's door." Before labor could achieve a more equitable arrangement with capital, it first had to address its own inequities.

MAD AS HELL

As John and Myrta Lewis toured the American South and Europe in May, June and July 1934, the fifty-four-year-old labor chieftain had ample time to reflect. Back home, things were finally beginning to look up for his UMW. A presumably labor-friendly president occupied the White House and had begun to deliver on his promise to give the American people a New Deal. Of more immediate importance to Lewis, both northern and southern coal operators, longtime mortal enemies, signed a contract with the union. It was just the tonic the UMW needed to emerge from its long malaise. Membership rolls leaped to more than 400,000, and the dues rolled in. Lewis found himself the undisputed master of the most powerful union in the country, in control of a swelling treasury with which to work his will. He returned home from Europe with one goal in mind: organize the unskilled workers, beginning with steel, into one colossal movement of twenty-five to thirty-five million with himself as commander in chief. Other players and uncontrollable events, however, would force him to alter strategy.

Even before the Lewises departed on their sojourn, workers in local hot spots around the country were reaching the point of rebellion, ready to take their grievances to the streets or docks. They were mad as hell—at their employers, Roosevelt, the lingering Depression, the AFL itself—and they weren't going to take it anymore. Specific issues differed from city to city, as did the category of worker—truckers, longshoremen, auto parts assemblers. The one constant was a demand for recognition, the right to bargain collectively with corporate management. Firebrand leaders far more militant

than John L. Lewis led bloody walkouts, oblivious to whatever Lewis may have had in mind for them and in open defiance of the AFL's hidebound graybeards. From early spring until mid-summer 1934, Minneapolis, Toledo, San Francisco and Portland, Oregon, became the scenes of some of the worst labor violence the nation had witnessed in years.

Many of the tactics employed by the police on one side and strikers on the other would be repeated three years later outside the Republic Steel plant in South Chicago. Each clash bore at least some of the same earmarks, most notably the very use of police and deployment or threatened deployment of the National Guard to control striking workers and defend corporate property. Strikers and their sympathizers, numbering hundreds and frequently thousands, pressed their cases for the most part with fists, clubs, rocks and other thrown missiles, slingshots, the occasional torch and—in limited, often unproven circumstances—gunfire. Stockpiling rocks or bricks before an expected confrontation was not uncommon. At Minneapolis and then at Chicago, strikers mobilized makeshift ambulance brigades to retrieve compatriots injured or wounded by the police. And at Minneapolis and Toledo, pickets tried to fight their way into city hall and a strikebound factory, respectively. Strikers who were repulsed twice outside the Republic Steel mill in Chicago denied that a takeover was their intent.

That Communist agitators participated in the explosive environment remains indisputable. The question that lingers after all these years is whether the tail wagged the dog or vice versa. The consensus appears to be that

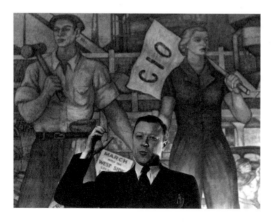

Walter Reuther, president of the United Auto Workers union (UAW), addresses a labor gathering while standing before a mural called *Ford Riot*. *Courtesy of the Walter P. Reuther Library, Wayne State University.*

Communists didn't start the symbolic fires but supplied gasoline once they got going. United Auto Workers (UAW) leader Walter Reuther and others on the left protested that mention of Communist participation amounted to "red-baiting." Nonetheless, party members and their acolytes constituted an active presence at labor disturbances throughout the country. At the same time, the alleged presence of Communists provided police

in some cities with a handy excuse for the disproportionate use of force against legitimate demonstrations.

In any labor faceoff, the authorities and the besieged companies they sought to protect invariably commanded the heavy artillery, not only in a manner of speaking but also sometimes literally. Soldiers armed with rifles and bayonets; police brandishing service revolvers and nightsticks; plentiful supplies; and the liberal use of tear gas and nausea-inducing chemicals, machine-gun emplacements, field guns and, in at least two instances, high-pressure blasts from fire hoses were among the deterrents. Given the imbalance, it's a wonder that many confrontations lasted for hours and then resumed in following days.

Trouble began bubbling in Minneapolis in March 1934 when several hundred teamsters organized a local of the Truck Drivers Union. Employers, with strong support from other anti-union industries, initially tried to ignore the new group and its demands for recognition, higher pay and redress of grievances. Negotiations failed, and a strike developed. The employers responded by creating a force of "special deputies" and handed them badges and clubs. A long spring and summer of industrial warfare was about to begin, but the first major battle didn't involve the truckers.

In early April, a mob of more than four thousand unemployed men and women demanding jobs and welfare payments converged on city hall and battled police for four hours. The mêlée began with a parade of several hundred that rapidly gained followers as it moved through the streets. When the marchers reached city hall, speakers climbed atop parked cars and harangued the crowd. The police moved in and ordered the gathering to disperse, but their order was met with a barrage of rocks, bottles and chunks of coal as demonstrators tried repeatedly to storm the building. Police responded with clubs and tear gas. Machine guns, mounted inside in anticipation of an attack, remained silent. Fifteen persons, including eight officers, suffered serious injuries. Thirty were arrested.

The most serious outbreak in the truck drivers' strike occurred in late May, when the employers sent their special deputies into the city's market district. There they confronted hundreds of pickets trying to prevent the loading of produce trucks that were to make deliveries to grocers whose supplies had been cut off. Two persons were fatally injured, including business and civic leader C. Arthur Lyman, who was acting as a special officer. Lyman suffered a fractured skull when he was clubbed from behind as he fought with a group of pickets. That someone of Lyman's stature was performing "riot duty" was no anomaly. Among the special deputies, the

New York Times reported, "were socially prominent persons who dropped their work in bond houses and grain firms to join the volunteers." One was a former Yale athlete "who wore a padded polo helmet" that set him apart from companions who donned football helmets. The other side also could claim at least one dignitary who showed up for combat. Among the seventy-five arrestees was U.S. congressman Francis H. Shoemaker of Minnesota. The *Times* said Shoemaker, "who has figured in encounters with the law here and in Washington," was armed with a broom handle. In addition to the two dead, sixteen policemen and nineteen pickets were seriously injured.

By early August, the crisis had cooled sufficiently to bring the striking truckers and their employers back to the bargaining table for face-to-face talks. It took almost another three weeks before an accord was reached that amounted to total victory for the union.

Other groups of workers around the country surely took note of the Minneapolis truckers' victory, as they no doubt did of some of the tactics employed during the struggle. On May 24, newspapers everywhere ran a stark wire service photo of a Minneapolis striker clubbing a special officer to the pavement. The unidentified victim may have been Arthur Lyman. The picture was not connected, at least directly, to news reports that same day from Toledo, where nine hundred Ohio National Guardsmen had been dispatched to restore order at the strike-bound Electric Auto-Lite Company plant.

The troops didn't have to wait long before they saw action. In fact, they may have arrived in the nick of time. Just before the soldiers were ordered out, company guards set up their own machine guns and trained them on a spot where the UAW strikers had torn a steel gate from its hinges. Earlier, strikers and their sympathizers had set a fire at the main gate. A throng scattered as responding firefighters extinguished the blaze. The assaults on the gates accompanied a siege that saw about 1,500 non-striking employees held prisoner inside the plant by strikers twice their number. At one point, strikers broke into the plant and fought hand-to-hand with guards and non-strikers, which Chicago police claimed was the intent of Republic Steel strikers three years later. After the Auto-Lite strikers had been beaten back, guards were ordered to fire at the legs of anyone attempting a repetition. After Republic strikers were turned back, police fired anyway.

The long day of skirmishes began soon after one hundred police officers arrived to protect day shift workers leaving the plant. A crowd that had been assembling adjacent to the factory stood ready. They'd been stockpiling bricks and stones at strategic points. Then, a wagonload of bricks rumbled in

to provide additional ammunition. Before a stone could be thrown, however, a barrage of tear gas bombs left the upper windows of the plant. A sixty-two-year-old salesman for Federal Laboratories Corporation of Pittsburgh, manufacturer of the gas bombs, was inside the plant at the time. E.E. Richardson told a Toledo police detective that special deputies threw the grenades out the windows, into the crowd, without pulling the pins, and the strikers threw them back through the windows, also without pulling the pins. "The special deputies," said Richardson, "were only deputized about two hours before they were using the grenades and did not have sufficient time to learn how to use them." Perhaps the company representative said something like, "Look, here's how it's done." "I picked up the same grenade, pulled the pin and threw it out the window with perfect results." The salesman said he didn't know how many gas grenades were thrown into the crowd, but apparently some of the workers helped themselves to supplies kept in boxes. "There were fifteen hundred employees in the plant at that time," Richardson noted. "These men weren't authorized to handle the grenades, but it was impossible to watch everybody."

Conditions got worse the following day. After the company decided to close the plant, an angry, jeering crowd numbering in the hundreds assembled one block to the east. It wasn't clear what provoked the troops, but they let fly with a barrage of tear gas and stench-producing bombs. Members of the mob responded with a hail of bricks while they tossed back some of the bombs. Twice the guardsmen were driven back to the factory walls, and twice they regained their lost ground with bayonets and the aid of reinforcements. When the strikers mounted a third charge, the troops were ordered to fire over the heads of the attackers. Still the mob advanced. That was when the guardsmen lowered their rifles and let loose with a second volley. Two men in their twenties, reportedly bystanders, were killed. About twenty were wounded, some by gunfire, others by missiles. At least ten soldiers were seriously injured by bricks, some thrown from rooftops as the strikers attempted a flanking maneuver during the battle.

Rioting in Toledo continued for a third day and night but began to taper off. Troopers fired rifles and pistols into the air when they felt the now-customary barrages of stones, bricks and bottles had become too heavy. On the fourth day, the disorders flared again as a National Guard lieutenant and a civilian bystander were seriously wounded. The officer was struck in the thigh by a .22-caliber sniper's bullet while he directed traffic at an intersection. The other man, a railroad fireman named Orville Kane, was spending a day off with two friends. They decided to drive to the Auto-Lite

plant to see what was happening. "Before I knew anything, something hit me right in the eye. It went right through the lid and lacerated the flesh from the corner of the right eye to the temple." Kane fell but remained conscious. His friends took him to a nearby house, where someone gave him a drink of water while one of his companions went for their car. Before the man could return, two policemen took the injured railroad man to a hospital. Kane spent nine days there, followed by four months at home "in pretty bad shape." Doctors removed his right eye and replaced it with a glass eye. When he tried to return to work, he said, he was told he'd been fired because the job required someone with two good eyes. He received no severance compensation. Despite allegations to the contrary, Kane strongly denied being an agitator or a picket or having anything to do with the union. He said he didn't see the object that hit him but was told it was about nine inches long and shaped like a bullet.

Despite the recurring trouble, there were signs of peace at hand. A flurry of moves by the UAW, management and federal mediators lifted hopes to their highest level since the strike began on April 13. An agreement was reached on June 3. All nine hundred national guardsmen departed the city, leaving only a few policemen to guard the plant as it resumed production.

While the Toledo strike was moving toward settlement, conditions on the San Francisco waterfront were deteriorating. Negotiations to settle a strike by the International Longshoremen's Association (ILA) that had shut down the largest port on the West Coast were getting nowhere after two weeks. On May 28, 1934, about one thousand strikers who had gathered on Pier 18 made a seemingly impromptu decision to stage a parade, just as striking steelworkers in South Chicago would do almost exactly three years in the future. A lone mounted police officer rode onto the sidewalk and tried to prevent the march. "As if a signal for the general outbreak," the *New York Times* reported, "fists swung, clubs flailed and rocks hurtled through the air" as the mob attacked the policeman. Other officers, backed up by reserves toting sawed-off shotguns, drew their revolvers but didn't fire. They did launch tear gas bombs that sent some of the crowd fleeing. A representative of tear gas manufacturer Federal Laboratories admitted firing a long-range projectile that caused one man to die of a fatal skull fracture. "As he was a Communist," the company rep explained, "I have no feeling in the matter and I am sorry that I did not get more." Those who stuck around fought pitched battles with the police. Two men were reported shot, but it was unclear by whom. Additional scores of people, including four policemen, were injured. When the mob dispersed after two hours, the police chief

massed five hundred officers on the waterfront. He refused to confirm or deny reports that machine guns had been brought in.

The adjutant general of the California National Guard used Independence Day to prepare his troops for immediate service if strikers defied the governor's intent to move traffic on the state-owned Belt Line Railway. The general warned would-be troublemakers that he would "not monkey with tear gas" but instead would employ a non-fatal agent that induced violent nausea and a splitting headache that could incapacitate a person for at least two days. Two thousand troops moved in when strikers tried to block railcars from entering a ship loading area. The guardsmen ran the strikers off the waterfront and onto an adjacent hill, where a deadly battle followed. Two were killed and more than one hundred injured on July 5. The *Times* identified one of the dead as a "member of a New York Communist group and a recent arrival in San Francisco." In another prelude of violence to come in South Chicago, he had been shot in the back. A wire service photo showed a lone rifleman—it's not clear whether he was a policeman or guardsman—aiming at a scattered band of civilians gathered on Rincon Hill near the waterfront. All appeared to be standing passively, some with their backs to the gunman.

The Guard, meantime, assumed full control of the docks, patrolling with fixed bayonets and walkie-talkies as they passed by lines of machinegun emplacements, several looking down from the tops of large sheds. The Belt Line moved more than two hundred cars without interference.

In a change of tactics the next day, the joint strike committee called on the city's 120 unions and their fifty thousand members to conduct a general strike. By a margin of more than four to one, the pivotal Teamsters Union answered the call. Scores of others quickly followed, and at 8:00 a.m. on Monday, July 16, the general strike went into effect. Union leaders fully understood the danger of a public backlash. Tying up all transportation except private cars, closing gas stations, paralyzing business, preventing people from obtaining food or getting to work and, for all intents, crippling a metropolitan area of 1.3 million could easily transform union members into villains.

Several reasons contributed to the collapse of the general strike. The most obvious was public opinion. People deprived of food, gasoline, a way to get to and from work and a normal lifestyle immediately begin looking for someone to blame, and the unions, not the shipping concerns, quickly found themselves wearing the collar.

Within an hour after the end of the general strike, San Francisco became a changed city. For the first time in four days, pedestrians, trucks, taxicabs,

streetcars and buses clogged the streets. Restaurants, movie theaters, bars and other places that had closed threw open their doors to throngs of happy customers. That night, according to the *Times*, San Francisco again claimed its place "as one of the liveliest, pleasantest, most exhilarating cities on the American Continent, instead of what appeared almost like a city of the dead at the zero hour on Monday morning, when nobody knew whether revolution, looting, rioting or what not was to be the outcome."

On the day the San Francisco general strike ended, the governor of Oregon ordered a regiment of the National Guard to mobilize for riot duty in a longshoremen's strike in Portland that had been overshadowed by the troubles affecting the larger city to the south. Eight days earlier, police had fired into a group of maritime union pickets who were trying to stop a freight train from running a union blockade near a municipal port terminal. When the strikers hurled a barrage of rocks at the locomotive cab and then tried to uncouple the cars, the officers guarding the train opened up. Four pickets were wounded, two seriously.

The Portland walkout had dragged on for eleven weeks, and the shippers were growing increasingly impatient with negotiations that were getting nowhere. Shipowners told Governor Julius Meier that the tie-up "can't go on forever" and served notice that they planned to move freight in and out of the port using nonunion labor. That was when Meier directed about one thousand guardsmen to an army camp about ten miles outside Portland and ordered them to stand by. The unions threatened a general strike if the troops were shifted to the waterfront. At least sixty and possibly more than one hundred unions representing some twenty-five thousand members stood ready to impede daily life with only a few exceptions. Hospitals, relief agencies, charitable institutions, milk deliveries and daily newspaper circulation would be exempted. It appeared that only the arrival of a highly respected emissary from Washington could head off the draconian job action.

Gunfire welcomed U.S. senator Robert F. Wagner Jr. of New York to the City of Roses. Wagner, representatives of the National Labor Relations Board (NLRB) and a group of union officials were inspecting a municipal terminal when shots rang out. The location was a place where numerous clashes had occurred between police and strikers. Special guards fired seven shots at Wagner and his party. No one was injured, but one of the shots struck the car just ahead of the one carrying the senator, a staunch advocate of organized labor and author of landmark legislation in the field. The guards fired from a dugout overlooking the terminal when the party allegedly failed

to obey an order to halt. Members of the senator's entourage denied that they had heard any such order. In fact, the driver of Wagner's car, a labor attorney, insisted that the group had been escorted by guards almost to the spot of the attack. According to the driver, the attack represented "a piece of monstrous stupidity." The four guards were arrested.

Senator Wagner shrugged off the incident and held a series of talks with union leaders and waterfront employers, as well as the governor and other business leaders. Labor men weren't so quick to dismiss the gunshots as a mistake, characterizing the matter as an unprovoked attack on their leaders as well as a United States senator. Similar outrage did not follow a police raid on Communist Party headquarters, where thirty-five alleged radicals were arrested on charges of violating the criminal syndicalism law. The raid was said to be part of a crackdown on "agitators" disseminating "inflammatory literature." Chicago unionists would experience their own problems with the police when attempting to distribute pamphlets.

The threat of a general strike diminished when the longshoremen took note of the public backlash created by the San Francisco job action. Another step toward a peaceful settlement came as longshoremen and the marine craft unions began voting on whether to submit their demands to arbitration. All the while, nonunion crews continued to load vessels in the harbor. As expected, the strikers voted heavily in favor of submitting all issues to the National Longshoremen's Board at San Francisco. The Portland dock strike, the last of four tumultuous labor upheavals in the spring and summer of 1934, officially ended on July 31 after twelve weeks.

THE STEELWORKERS ORGANIZE

The toll from the conflicts in Minneapolis, Toledo, San Francisco and Portland amounted to at least 7 dead, 9 wounded by gunfire, 150 hurt by other causes, untold numbers of shots fired and countless demonstrators gassed and arrested. Yet as violent and precedent-setting as they were, these battles would present footnotes, both in terms of bloodshed and national labor relations, to developments of far more lasting significance over the next few years. By the end of 1934, 700,000 workers had gone on strike across the country. In May 1935, employees of Republic's Berger Manufacturing Division in Canton, Ohio, joined the ranks—briefly. The company responded by purchasing munitions, hiring extra guards, importing strikebreakers from out of town and retaining the Hill and Knowlton public relations firm to smooth over its heavy-handed tactics. Company police attacked a picket line outside the plant gate, resulting in twenty-eight hospitalizations. The strike was broken. Afterward, Tom Girdler ordered his guard force "to avoid violence of every kind" and leave law enforcement to the local authorities, an admonition that Girdler's Chicago people would follow scrupulously two years later. "These were times of hate and anger," Saul Alinsky observed. "Everyone wanted to hit out, employer against worker, worker against employer and anyone else they felt not in their class. Many of these [non-skilled] unions turned to the AFL for help." The federation's answer, in so many words, was "vacillation, equivocation and red tape," according to Alinsky. John L. Lewis didn't need to be knocked off his horse on the road

to Atlantic City, site of the AFL's 1935 convention, to understand that the time had come to make his move.

As President William Green gaveled the conclave to order, the choice facing the delegates couldn't have been more clear-cut: maintain the status quo or accept the mass production unions. Lewis delivered an emotional appeal for inclusion by asserting that the labor movement stood on a principle that "the strong shall help the weak." There was also a practical consideration. Conditions were changing rapidly, he maintained, and the day might be coming when the craft unions would need the support of their industrial counterparts.

For the UMW leader, the speech marked a complete turnaround from his days with Sam Gompers, who was grooming the younger man to become his point person to head off what he saw as encroachment by the unskilled workers. "The ghost of Gompers" hovered over the AFL of the 1930s, Dubofsky and Van Tine intimated, threatening to make it impotent in the face of new times. "Lewis, the perfect union politician, was also the complete chameleon, always ready to change colors to suit a new milieu. A man who previously transformed himself from a Wilson Democrat to a Coolidge Republican, a union militant to a 'labor statesman,' a bankrupt grain dealer to a successful banker could easily…play the multiple roles of ardent New Dealer, AFL rebel…and class warrior." The convention delegates weren't buying the appeal of the "new" John L. Lewis and voted against inclusion by a margin of more than three to two.

Lewis's immediate response to the AFL rejection, the day after the convention ended, was to invite eight like-minded labor colleagues to breakfast at the President Hotel in Atlantic City. These leaders included representatives of the printers, textile and clothing industries. Lewis encouraged them not to let the setback deter them from their objective of organizing the mass production workers. Less than three weeks later, the group added two members and reconvened at UMW headquarters in Washington, where, on November 9, 1935, the CIO was born. On August 4, 1936, the AFL expelled the CIO faction for heresy, as it were.

The insurgents hadn't waited for the seemingly inevitable. One month earlier, the CIO had announced formation of the Steel Workers Organizing Committee (SWOC) to carry out Lewis's long-cherished strategy of making the steel industry the first target of his mass unionization campaign. "A tremor in steel would reverberate noisily in mills and factories in every corner of the land," according to David F. Selvin in *The Thundering Voice of John L. Lewis.* "If we can organize here," Lewis was quoted as saying, "the

rest will follow…If the crouching lion can be routed, it is a safe bet that the hyenas in the adjacent bush may be scattered along the plain." CIO matters might have been in the forefront at the moment, but John L. never forgot that he was the boss of the United Mine Workers and that their future was tied to that of the steel industry. "As long as Big Steel is free to tack up a sign at a single pit head announcing a wage cut, the United Mine Workers are in danger of becoming, as they were once before, a mere 'rear guard' of labor's retreat to cooliedom," Lewis warned.

SWOC was born on June 17, 1936, in Pittsburgh. Its parent, the CIO, in cooperation with the foundering Amalgamated Association of Iron, Steel and Tin Workers, offered up to $500,000 in seed money. The newborn group's stated purpose was "undertaking the gigantic task of organizing the steel industry" in "the spirit of responsibility to the whole labor movement." SWOC was christened four days later on a sunny Sunday afternoon along the banks of the Monongahela River at McKeesport, a steel town outside Pittsburgh. Flanked by a pair of American flags, speakers utilized the bed of an old coal-hauling truck to address a goodly gathering of steelworkers and coal miners. They heard Philip Murray, appointed chairman of SWOC by his longtime sponsor John L. Lewis, vow, "The drive to unionize the steel industry will continue if it takes ten years!" The meeting was held at the McKeesport city dump because the mayor had forbidden union organizers from meeting anywhere in town.

Phil Murray was the classic understudy, the bridesmaid, the second banana. He'd spent seventeen years in the literal and figurative outsized shadow of John L. Lewis, carrying out the boss's orders as his handpicked vice-president of the UMW. An Irish-Catholic who grew up in Scotland, Murray and his family immigrated to the United States in 1902 when Phil was sixteen. Like Lewis, he followed his father into the coal fields and the tumult of union activism. Also like Lewis, he quickly rose through the UMW ranks. But apart from their mutual belief in the righteousness of organized labor, Murray represented the un-Lewis in virtually every respect. While the leader relished the finer things in life, the aide-de-camp and his wife had lived, as of 1936, in the same modest Pittsburgh home for twenty years. Spending quiet Sunday afternoons at his sister-in-law's provided a favorite diversion from labor struggles. A 1946 profile in *Life* magazine invoked the word "humble" four times in a single paragraph. Two paragraphs later, the writer referred to "the humble religious Murray," and lest the reader forget, the piece concluded by mentioning the "prime fact to remember is that Phil Murray is a gentleman." True enough. Anyone

reading the press of the day or historical accounts would find it difficult to discover an unkind word spoken or written about him. He even charmed Henry Ford. Tom Girdler was impossible to charm. The Republic Steel boss told a U.S. Senate committee in 1937, "Mr. Murray is a liar and so far as I know he always has been."

A man of plain dress, thinning silver hair and pronounced dark eyebrows (but nowhere near Lewis proportions), Murray appeared older than his fifty-one years in 1937. He looked the part of the studious detail guy who counterbalanced Lewis's *Sturm und Drang*. The new steel union leader had never worked a day in a mill, but when Lewis tapped him to lead SWOC, he devoured everything he could read about the industry. He soon became as knowledgeable as any of the corporate executives with whom he matched wits.

Lewis and Murray experienced only one significant disagreement prior to the 1937 steel strike. In 1932, the boss opted to renew his membership in a mythical, esoteric club that could have been called the League of Republican Labor Leaders. Lewis backed President Hoover for reelection, while Murray and nearly every other union boss supported Governor Roosevelt.

The humble Irish/Scot immigrant lost no time getting SWOC off and running. His organizers seemed to be everywhere, opening headquarters in places where "union" might just as easily have referred to the Union army or a union suit. "Signs have been carried in streets where no union ever before dared to raise its head," *Fortune* magazine reported. "And practically every day meetings are held in that vast territory, openly or furtively, in parks, in convention halls, in cockeyed shacks on the edges of town or even on isolated farms rented for the occasion." In a brilliant symbolic stroke, SWOC staged a giant Fourth of July rally in Homestead, Pennsylvania, where a bloody steel strike had been ruthlessly crushed in 1892.

Understandably, the burst of organizing activity, on the heels of the violent outbreaks of 1934, set off alarms in the corporate offices of the steel industry, which reacted on two levels. First, companies responded with a newspaper ad campaign that accused "outsiders" of running the SWOC campaign. The union's intent, the industry claimed, was coercion, intimidation and the instigation of strikes aimed at the creation of the closed shop, which required all employees to join the union. Steel employers would fight any effort "to compel its employees to join a union or pay tribute for the right to work," in words quoted by author David F. Selvin. Besides, the companies added, employees already belonged to Employee Representation Plans. Total cost of the anti-union ad campaign came to about $500,000, or

close to the amount the CIO and Amalgamated had invested to launch the entire SWOC operation.

If the industry's second response was intended to trigger alarm bells in the union's ranks, it not only worked but caught the attention of a congressional subcommittee as well. Steel companies had increased their purchases of guns, clubs, tear gas grenades, projectiles and gas masks. A subcommittee of the Senate Labor Committee, chaired by Senator Robert M. La Follette Jr., of Wisconsin, had been tracking the purchases under its mandate to investigate violations of labor's rights, which also included the use of espionage, strikebreaking and repression by private police. In 1925, La Follette at age thirty had become the youngest member of the Senate since Henry Clay when he succeeded his deceased namesake father, a lightning rod of Wisconsin politics since the turn of the century. "Young Bob" belonged to the Progressive Party of Wisconsin that his father had launched after becoming disillusioned as a Republican. The *Chicago Tribune* invariably labeled La Follette Jr. (Radical, Wis.)

Subcommittee records showed that Federal Laboratories of Pittsburgh had been doing a brisk business with the steel firms. Where steelmakers saw peril, the tear gas makers saw a bonanza. In a memo from Federal Labs vice-president B.H. Barker to all company salesmen, dated September 29, 1933, the official declared:

> *Prison breaks, labor strikes, bank robberies, disturbances of all kinds are of such frequency that the field for our activities is almost unlimited...Unlimited quantities of tear gas business have been secured in the local* [Pittsburgh] *area...Police departments are thoroughly upset over the present day trend of criminal activity...Capitalize on this opportunity. Let nothing keep you from getting yourself well entrenched and in position to be of service.*
>
> *The chance of a lifetime is within your grasp. Strikes cannot be broken with one or two grenades or a .38 shell. It is essential that this idea be put across. Don't pass up this opportunity.*

In another example of revealing correspondence, a Federal Labs representative, reporting to headquarters from Cleveland, told of suggesting to a client (whose identity is unclear) "making up a dozen or so [gas] samples for him to try out on a crowd, but asked them to use their own judgment...as I didn't want to be on record as making any suggestions on the subject. However, [the client] did say he would order a hundred or two at once if the samples were strong enough to do the trick."

It was a seller's market, no doubt about it. The day after Barker's marching orders to his salesmen went out, Bethlehem Steel ordered twenty-four military firing mechanisms, twenty-four jumbo gas grenades, forty-eight one-inch-caliber (gas) projectile shells, twenty-four one-inch-caliber short-range (gas) shells, four riot guns and four riot gun cases, along with other munitions and equipment. On June 6, 1934, during the spring and summer of widespread labor violence, Youngstown Sheet and Tube "acquired enough deadly firepower to stage a war against a small country," in the words of a 2007 United Steel Workers publication. Youngstown bought ten riot guns with cases, sixty long- and sixty short-range (gas) projectiles and two hundred (gas) grenades along with other weaponry.

As early as September 25, 1933, Republic placed an order with Federal Labs for 64 guns, including 24 Smith and Wesson .38-caliber military police revolvers for use at its Youngstown, Ohio plant. A letter from Federal Labs to Smith and Wesson in Springfield, Massachusetts, confirming the purchase, is particularly instructive: Republic apparently didn't want its fingerprints on the order. "Your particular attention is directed to the fact that the shipment is to be made to our representative and not to the customer (Republic)... The customer is anxious to secure the quickest possible delivery date." Less than a month later, Republic-Youngstown seemed to have overcome its apparent shyness. Between October 13, 1933, and February 26, 1936, the plant bought 139 revolvers directly from Smith and Wesson. According to the steelworkers' union, Republic also formed a small cadre of guards and equipped them with Thompson submachine guns. The company went on to amass an arsenal that included 552 revolvers, 64 rifles, 245 shotguns, 143 gas guns, 4,033 gas projectiles and 2,707 gas grenades, along with an undetermined number of nightsticks and gas revolvers, according to Jerold S. Auerbach in *Labor and Liberty: The La Follette Committee and the New Deal*. A Republic vice-president justified the purchases as necessary "to repel an invasion" during a strike. Of all the weapons, gas provided the "most humane way" of protecting life and property, corporate officials and munitions suppliers agreed. If Federal or its employees didn't have any use for domestic Communists, the company drew the line at the water's edge. Auerbach noted that Federal sold tear gas and gas equipment to the Soviet Union's American purchasing agent. The company had no controversy with communism in Russia, one of its officials declared.

Adding up all the munitions purchases from 1933 through June 1937, the Senate subcommittee found that "$1,255,312.55 worth of tear and sickening gas was purchased by employers and law enforcement agencies

chiefly during or in anticipation of strikes." The biggest spender was Republic, with orders of $79,712.42, "four times as much as the largest law enforcement purchaser." U.S. Steel accounted for $62,028.12; Bethlehem Steel, $36,173.69; and Youngstown Sheet and Tube, $28,385.39. "The principal purpose of such weapons is aggression against unions...and hampers peaceful settlement of industrial disputes," the subcommittee concluded. "Their use invites retaliatory violence."

"If the nation's surplus World War I tools of destruction were not sufficient," the steelworkers' 2007 article continued, "Chicago's and Youngstown's local police force[s] were also mobilized to batter the working class back into its subordinate social position." Lewis wondered how any man could go to church on Sunday and worship God, "knowing all the while that on Monday the company he represents will embark on a campaign of killing."

Republic's Tom Girdler had a ready answer; his company was besieged by Communists. Republic, he said, had been closely monitoring the CIO's organizing campaign (with much of the intelligence gathering done by company spies and private detectives, he neglected to mention). "An ominous fact was repeated...about some of these fellows [organizers]. They were Communists. Not all, but many," Girdler declared in his autobiography. "Therefore, we had to defend the property and the workers of the corporation as best we could under outrageous handicaps," as if to say membership in the party, in and of itself, presented an armed threat.

The Republic leader may as well have announced the discovery of Lake Erie and saved his company the cost of the investigation. This wasn't the stuff of cloaks and daggers; Communists were everywhere, working in the open. No less an authority than William Z. Foster, national party chieftain, presidential candidate and leader of a 1919 steel strike, estimated that sixty of SWOC's two hundred organizers were active Communists. "Every place where new industrial unions were being formed, young and middle-aged Communists were working tirelessly," Saul Alinsky wrote. But where the Republic Steel boss saw a threat to the American way of life, the leftist organizer saw practical necessity. "The CIO was waging economic war, and as do all organizations and nations in time of war, it welcomed allies wherever they could be found."

The embrace was mutual. Communists, too, were looking for all the friends they could find. These were the days of the Soviet Union's United Front policy, which called for cooperation with the socialist parties of the West in a unified stance against Nazi Germany. In the United States, where party members of 1936–37 took their orders from Moscow, Communists

worked in tandem with the Socialist Party, Socialist Labor Party, International Workers of the World (IWW, or Wobblies) and other kindred spirits whose goal was the organization of America's production workers. The Communist Party was the largest of these groups in the General Motors town of Flint, Michigan. Veteran autoworkers organizer Genora Johnson Dollinger might have been referring to the Elks Club when she said the Communists in Flint "had a lot of social activities, dances and political meetings. They also had an insurance organization, the Industrial Workers Order." In a memoir told to Susan Rosenthal, Dollinger recalled that Robert Travis, the top UAW organizer in Flint, was in the Communist Party, and he selected Roy Reuther (brother of UAW chief Walter) to work as his second-in-command during the 1937 General Motors strike.

Members of the party also secured positions on the staff of the La Follette subcommittee, according to Auerbach, although the chairman conceded to a friend sometime later that he'd been "hoodwinked" into hiring them. Some of the subcommittee's "most active and crucially placed staff members had been warmly sympathetic to the objectives of the Communist Party," the author wrote. The key player was counsel John J. Abt, who brought a number of others on board. Abt, in turn, had been recommended for his job by Lee Pressman, CIO counsel and one-time party member, who said he, Abt and subcommittee investigator Charles Kramer had been members of the same cell. Defending the makeup of the staff, its secretary, Robert Wohlforth, echoed John L. Lewis when he said, "If the Labor Board or the Bureau of Labor Statistics sent me somebody, I wasn't going to put him in a corner under a bright light and beat him with a rubber hose." Nonetheless, Auerbach stated, "With a nucleus of at least half a dozen staff members sympathetic to Communist Party doctrine, it is not surprising that incidents were selected, witnesses chosen, and reports drafted that stressed the theme of class warfare and placed responsibility for it squarely on the shoulders of American capitalists. Industrial tyranny was a fact—and the La Follette Committee performed a genuine service in exposing it. Yet the committee, by producing a composite portrait of the American industrialist as an armed practitioner of class violence, probably did more to buttress the Communist Party line than any other New Deal institution."

Many Americans shared the opinion of Tom Girdler and other business leaders that the goal of the CIO and its allies was the "sovietization" of American industry, a system directed by "workers' councils" instead of corporations and their executives. Girdler viewed the supposed challenge with trepidation. Future historians, he believed, would see the emergence

of the CIO "as the most significant manifestation of a conspiracy that may change the course of the American people." John L. Lewis himself would not have disagreed that the CIO was determined to change the direction of the country. He accused the steel industry of issuing a "declaration of war" for an impending "battle for democracy." Before a steel industry–CIO showdown could begin, however, "all hell broke loose" at General Motors, in the words of one of its very beleaguered executives.

DETOUR

All the beat-up workers at General Motors wanted was a little respect and an opportunity to bargain collectively with management on union recognition, assembly line speedups, wages and health and safety issues; for years, all they got was the runaround. "We're human beings," they reminded themselves. "Was it asking too much to be treated as humans?" While nearly 60 percent of the strikes in the United States at that time were over union recognition, speedups were the biggest issue with most GM line workers. Charlie Chaplin drew laughs when he portrayed a harried worker trying to keep up with an ever-faster assembly line in the movie *Modern Times*. In real life, speedups were hardly a laughing matter. "They had men with stop watches timing the workers to see if they could squeeze one or two more operations in," union activist Genora Dollinger remembered. "They did everything but tie a broom to their tail...The men just couldn't take it. They would come home at night and they couldn't hold their forks in their swollen fingers." When employees tried to raise such issues with senior management, they were told to take their problems to plant managers, who turned deaf ears.

GM employees thought this pattern would begin to change in 1934 when the AFL, which had held them at arm's length, agreed to create a new division, a so-called federal local or network of autoworker locals reporting directly to national headquarters and not tied to any of the clannish individual craft jurisdictions. GM workers, many of whom were itching to strike, were jubilant. Now they stood ready to take on the company with some real clout behind them. Thousands rushed to join up, but GM made

clear in a number of meetings that it had no more intention of bargaining with the AFL than with unorganized workers.

In Detroit, the UAW could claim not many more than 1,000 members of a possible 250,000 eligible. It was the same story in Flint, where slightly more than 100 belonged of more than 40,000 eligible. Apathy wasn't the reason for the sorry totals, according to Dollinger; it was fear. "The workers knew conditions were horrible," she said, "but they were in fear of losing their jobs if they refused to join the [Flint] Alliance [a GM support group]. They also saw what happened to some of their buddies who would go to a union meeting and get beaten up [by company thugs] and come to work the next day with black eyes or a busted head."

The later consensus among union organizers was that GM greatly overestimated the UAW's early strength, otherwise it would have moved even more aggressively to smash incipient strike activities. GM's misreading of the union's power was particularly surprising because the company spent nearly $840 million for corporate intelligence during a two-and-a-half-year period in the mid-1930s. GM's size and power were truly intimidating. "In 1937," Alinsky wrote, "(GM) employed 261,977 of the approximately 400,000 in the entire industry." Its net worth amounted to more than $1 billion; its annual payroll stood at $460 million. The company produced 2.1 million cars and trucks at fifty-seven locations in the United States and Canada. But like a savvy judo practitioner, the UAW knew where to apply pressure to topple a much larger and stronger opponent.

Just as all roads were said to lead to Rome, the parts manufactured throughout the General Motors empire found their way to assembly lines in Detroit. The UAW didn't command a fraction of the manpower it needed to shut down the far-flung behemoth in one stroke, but if it could halt production at two key "feeder" plants, it could bring the entire system to a standstill. Along with a Fisher Body facility in Cleveland, union leadership targeted the Fisher Body Plant No. 1 in Flint. All the stampings for Chevrolet were manufactured in Cleveland, while Flint turned out integral parts for Buick, Oldsmobile, Pontiac and Cadillac. An estimated three-quarters of GM's total production was dependent on these two facilities.

Sporadic mini-strikes had been flickering and dying for weeks in various locations before the Cleveland workers sat down on the job on December 28, 1936. The move was spontaneous; no union leader issued an order. The workers took strategy into their own hands, Henry Kraus wrote, "and a surprise sit-down in one department swiftly spread throughout the entire

factory. The local union men hardly knew what to do with the strike. They, too, like almost everyone else had expected Flint to take the lead."

John L. Lewis not only didn't instigate the strike, but he also wasn't even consulted. No matter. He was smart enough to board a train leaving the station when it would take him where he wanted to go, even if it wasn't his first intended stop. The steel industry would have to wait. On the evening of the twenty-ninth, Lewis told a national radio audience that the GM workers could count on the CIO's full support and that it was high time the Democratic Party and its leader in the White House did the same for all organized labor and working-class voters. Lewis and the mine workers had contributed $500,000 to Roosevelt's 1936 reelection campaign and were looking for payback.

The following day, December 30, brought sit-downs at Fisher 1 and 2 in Flint, along with two other GM plants. Three more followed, and before long, fifteen GM facilities across the nation were on strike. Sit-down strikes had been happening in the United States at least as far back as Homestead in 1892, but by 1936–37, no one, not even the GM strikers, was sure they were legal. (Congress outlawed them soon after the GM strike.) The strategy held a number of built-in advantages. Most important, the strikers controlled the means of production. After they had stopped the assembly lines, there was no practical way the company could replace them with strikebreakers.

The combatants fired up their propaganda machines and bombarded the public with pronouncements. Locally, GM enjoyed a huge advantage in the war of words. Dollinger maintained that the *Flint Journal*, like the rest of the city, was controlled by General Motors, a not unreasonable conclusion. "They wrote things like, 'You don't bite the hand that feeds you,' and 'These people coming in are all imports from Soviet Russia, and they want communism.' So everybody was labeled a Communist who joined the union. The radio stations…and every avenue of information [were] controlled by GM." The twenty-three-year-old Dollinger, who spent the strike on the front lines outside the plants, said the union's only answer at first was mimeographed sheets later followed by a weekly newsletter. Distribution at the plant gates, she said, risked a beating by the company's police and private detectives. Their only other communication tool was a sound car, "an ordinary car fitted with loudspeakers on top with large batteries." The car would visit plants that hadn't gone on strike, and the vehicle's spokesman would urge workers changing shifts to join the cause.

Sound cars or trucks played an important but overlooked role in the CIO's ongoing organizing campaign, according to Alinsky. During picketing, the

voice coming from the vehicle was like that of a cheerleader bolstering morale. Sound trucks also served as mobile field headquarters with the person at the microphone directing troop movements. And they proved effective. "Employers were driven to a frenzy by the constant rolling bombardment on their workers emanating from these loudspeakers on wheels," the Lewis biographer explained. He might have added that they had a similar effect on the commander of the police assigned to protect Republic Steel's South Chicago plant in 1937.

Third-party voices joined the rising crescendo. Father Charles Coughlin, a Detroit priest and host of a national weekly radio program called Social Justice, became involved. A sort of Huey Long in a Roman collar, offering economic panaceas, Father Coughlin was viewed by many as a crackpot but boasted a wide following among working-class Catholics as well as others disillusioned by seven years of depression. In week two of the strike, Father Coughlin used the airwaves to lash out at Lewis and the CIO, saying he would never support an organization whose aim was to "sovietize" industry. Perceptive listeners heard an echo of the GM party line. Father Coughlin's superior, Bishop Michael Gallagher, branded sit-down strikes "illegal and Communistic." Speaking to a congregation, the bishop said, "The Communists advocated these strikes [in France]—often followed by riots—as a smoke screen for revolution and civil war." How much weight such opinions from the clergy carried with Catholics in general and Catholic police officers in particular is impossible to tell. However, few people, big-city police officers included, lived in a news vacuum. Combined with anti-Communist rhetoric from Tom Girdler, other captains of industry, political leaders and segments of the media, the words of prominent clergy fortified the message: Communists and communism were malignant invaders that needed to be repelled. Within this context, it shouldn't have been surprising that, less than five months later, one Chicago policeman whose colleague shot and killed a strike demonstrator partially justified the action by identifying the victim as a Communist.

The first serious outbreak of violence in the Flint strike began on January 7 outside Chevrolet Plant No. 9, and the use of sound equipment apparently provided the spark. No vehicle was involved, but a group of union loyalists had set up a pair of amplifiers above a tavern across from the plant that was serving as a temporary strike headquarters. During a change of shifts, a group of employees stopped to listen to what was being said. Henry Kraus, who, like Genora Dollinger, participated in as well as recorded strike activities, explained what happened next:

Suddenly a knot of men, later identified as chiefly foremen and superintendents, came out of the plant yard, crossed the street and engaged the union group with their fists. In the mêlée, Irven Carter, an assistant superintendent, smashed the sound equipment with a hammer. It was not till after the damage was done that the police came. They escorted the company group back to the plant and then returned to arrest two of the union men, both of whom had been hurt in the fight. They were thrown into jail and held incommunicado while the Beer Vault, the tavern that had rented space to the union, was closed as a warning to other small storekeepers in the neighborhood.

The Battle of the Beer Vault was only the warm-up for what happened on January 11 and 12. That was when Dollinger said General Motors finally decided that it had to break the strike. The assault began when guards at Fisher Body No. 2 prevented food from entering the building. Then they shut off the heat in sixteen-degree weather, but these moves were intended merely to soften up the occupiers for what was to come. The police shot tear gas into the plant before opening up with their guns. "The bullets came peppering, splattering against the building and dinging through the windows," Kraus recalled. Next, the attackers turned their weapons on a large group of pickets who had gathered in front of the plant. "The police were using rifles, buckshot, firebombs and tear gas canisters," Dollinger stated. "We had thought that General Motors would try to freeze us out or do something in the plants, but never open fire on us right in the middle of the city." Fourteen strikers were wounded, most by shotgun blasts. Only one was critically injured, the result of a bullet to the abdomen. And yet the strikers fought back, inflicting bodily injuries to about a dozen city policemen and sheriff's deputies.

General Motors found itself running out of cards to play. Like Gulliver tied down by the Lilliputians, the giant watched helplessly as its vast manufacturing network inexorably ground toward a halt. Rather than lend support, moral or practical, rival automakers happily fattened their shares of the market at the expense of Number One. To squeeze GM further, the CIO helped the competing companies by calling off strikes in the aluminum and plate-glass industries that were impeding the flow of those automobile components.

While the company's top brass was in Washington or New York, GM lawyers were busy in Flint. They asked a judge to issue an injunction ordering all sit-down strikers out of the plants. Judge Paul V. Gadola complied, giving

the occupiers twenty-four hours, or until mid-afternoon on February 3, to clear out or see the UAW face a $15 million penalty. Judge Gadola also prohibited further picketing.

Outside the courthouse, as the case was being heard, union sound cars roamed the streets to drum up attendance at a purported demonstration on the building lawn to protest the use of injunctions in labor disputes. The announced demonstration never occurred; it represented a feint as several hundred strike sympathizers instead marched on Chevrolet Plant No. 9, which was still operating. The throng included about twenty members of a "Women's Emergency Brigade" wearing red berets and red arm bands. It was led by Genora Dollinger. (A like contingent would join the march on Republic Steel's Chicago plant later in 1937.) The move on Plant No. 9 was diversionary, too. "We wanted GM to put all its guards on Plant 9 and leave Plant 4 [about a half mile away] free to be taken," Dollinger explained. "I had the Brigade out there, marching up and down in front of Plant 9. When the police saw the Brigade, they came and formed a line. At one point, the police pulled their revolvers and threatened the union men on the outside because they knew the plant police were taking care of the men inside" who had staged sit-downs at various points of the plant. When the strikers began to shut down some of the machines, Dollinger said, the guards resorted to beatings and tear gas. Outside the gates, meantime, more battles flared when the assembled crowd of sympathizers tried to prevent non-strikers from entering the plant, and additional police arrived to protect the incoming shift. Both sides wielded heavy clubs and blackjacks, even the women, who used the weapons to smash windows in the plant. Dollinger said they did it so the men inside could get air.

Four thousand troops, the entire Michigan National Guard, were now assembled in Flint, awaiting orders to enforce the court injunction and clear out all sit-down strikers. From inside the plants came defiance from men who had fought so hard and endured so much that they weren't about to give up now that the occupation had passed the one-month mark. The occupiers sent a telegram to Governor Murphy that read in part, "Unarmed as we are, the introduction of the militia, sheriffs or police with murderous weapons will mean a blood bath of unarmed workers…Governor, we have decided to stay in the plant…We fully expect that if a violent effort is made to oust us many of us will be killed and…you are the one who must be held responsible for our deaths!"

If Governor Murphy had reached his wits' end, General Motors, CIO leadership, strikers inside and outside the plants and the man in the White House

were nearing theirs. President Roosevelt made repeated phone calls to the principals in the negotiations, urging them to settle their dispute that was leading to industrial warfare on a larger scale and jeopardizing the nation's economic recovery. Not an illogical conclusion to be sure, but Lewis said he discovered that the president was playing a double game— telling him that as far as he was concerned, the sit-down strike could continue while telling Murphy in a separate conversation that he wanted

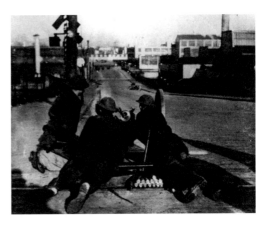

Michigan National Guardsmen man a machine gun on the road leading to the Fisher Body Plant during the GM sit-down strike in Flint. *Courtesy of the Walter P. Reuther Library, Wayne State University.*

the sit-downs ended. Alinsky said Lewis told him in an interview that this was when he "discovered the depths of deceit, the rank dishonesty and the double crossing character of Franklin Delano Roosevelt." The rift never healed.

On the night of February 9, all National Guard units were placed on alert. Troops prepared to seal off highways, railroads and every other possible entryway to Flint to prevent the CIO from moving in strike reinforcements. In the occupied plants, the sit-down strikers, nervous and worried, braced for an onslaught, unsure of what form it would take. The Guard's arsenal included field artillery.

John L. Lewis remained immovable from his demand for recognition of the UAW as the sole bargaining agent in twenty-three strikebound plants. Company officials began to have second thoughts about the wisdom of pushing the governor to the wall. What if there was a fight to the death, blood on the factory floors and in the streets, arson, massive property destruction? Maybe they, not the governor or the strikers, would suffer the condemnation of the entire country and the car-buying public in particular. Just when Governor Murphy thought his borrowed time finally had expired, GM blinked. At 2:45 a.m. on Thursday, February 11, 1937, Murphy addressed an assemblage of more than fifty newspapermen at Detroit's Hotel Statler like a man who had just been granted a reprieve from the gallows. Agreement had been reached to end the forty-four-day strike.

The pact was signed at noon. It was presented in a way to appear that neither side had backed down, although the bargain obviously represented a smashing victory for the UAW, the CIO and John L. Lewis. The major provisions of the deal stated that GM would recognize the UAW as the sole bargaining agent but at only twenty of its sixty-nine plants. The union, in turn, agreed to call off the strike and evacuate the factories. Operations were to resume at once, while bargaining on wages, hours, speedups and other issues would begin in five days. The National Guard packed up and went home.

MR. LEWIS AND MR. TAYLOR HAVE LUNCH

E ighteen years in the future, General Motors CEO Charles E. Wilson would famously proclaim, "What's good for General Motors is good for the country." In 1937, John L. Lewis could have remarked, with less hubris but more accuracy, "What's good for General Motors is good for Chrysler." The ink had barely dried on the UAW agreement with GM when union militants on March 8, 1937, staged a sit-down strike against a second automaker. Other things also remained the same. Lewis came riding into Detroit to take command of the CIO-UAW side of the negotiations. Frank Murphy, probably feeling more like a professional labor mediator than a governor, arrived from Lansing. But some things were different. In the less than four weeks since the GM agreement, a subtle change had occurred in the mood of the country. People seemed less forgiving of tactics that included sit-downs, violence and dramatic confrontations. In the view of Lewis biographers Dubofsky and Van Tine, "The governor of Michigan and the president of the United States perceived greater political gain in enforcing the law than in 'appeasing' strikers. Murphy prepared to use force to evict the Chrysler strikers, and Lewis, ever the realist, quickly worked out a peaceful accommodation with the governor and company negotiators."

When the talks opened, Chrysler was willing to grant the union everything it won from GM. The UAW, echoing old Sam Gompers's one-word summation of labor's ultimate goal, wanted "more." GM had extended bargaining rights to the UAW at only twenty of sixty-nine locations. Now, the union was demanding exclusive representations for all eligible Chrysler employees. The company refused, and the sit-downs began. "After a typical round of bargaining," Dubofsky and Van Tine observed, "in which Lewis

threatened one Chrysler executive with physical force and exposed another to ridicule, he accepted a strike settlement identical in every respect with the earlier General Motors agreement." A thirty-five-day strike was the price paid to reach square one.

The Chrysler agreement provided only a footnote to what many agree was John L. Lewis's greatest triumph. So casually did the story unfold that Lewis biographers disagree on when the CIO boss began a series of meetings with U.S. Steel chairman Myron C. Taylor. In *Labor Baron*, James A. Wechsler maintained that the two men "who had known each other from the time of (the New Deal's) NRA," began meeting informally in December 1936 at Taylor's Fifth Avenue town home in New York and continued their conversations at Washington's Mayflower Hotel. "Bull sessions," Wechsler called them. Other biographers, among them David F. Selvin in *The Thundering Voice of John L. Lewis*, cited a *Fortune* magazine article describing a starting point that is both more precise and anecdotal. All accounts have Lewis eating lunch at the Mayflower on January 9, 1937, less than two weeks after the sit-downs began at Cleveland and Flint. The CIO leader was dining with his good friend Senator Joseph Guffey of Pennsylvania when Taylor and his wife entered the room. As Mr. and Mrs. Taylor passed Lewis and Guffey, the men nodded. After the steel executive seated his wife at their own table, he returned to Lewis and the senator. The three men chatted for a moment before Guffey excused himself. Lewis and Taylor continued to talk until the CIO chief finished his meal, and the conversation resumed at the Taylors' table.

Mrs. Taylor, so the story goes, asked Lewis, "When is the trouble going to stop?"

"When your husband sits down and writes an agreement," came the reply.

"What are you doing tomorrow?" Myron Taylor asked.

Mrs. Taylor reportedly was favorably impressed by Mr. Lewis.

The two men started—or continued—a long series of discussions the following day in the Taylors' Mayflower suite and kept the dialogue going over a period of days until Lewis was called to Detroit to take personal charge of the General Motors negotiations. Their secret talks didn't resume until two weeks later, when Lewis went to New York to take part in negotiations between his miners and the coal operators. For the next two weeks, Lewis and Taylor kept talking at the steel executive's home. Casual discussions segued to exchanges of proposals for a contract between U.S. Steel and the CIO's SWOC. The very hint of such an outcome would have been unthinkable a year or possibly even months earlier. Not for nothing was this

colossus, by itself, called Big Steel. All the other major players, collectively, were known as Little Steel (Republic, Bethlehem, Inland, Jones & Laughlin, Youngstown Sheet and Tube). U.S. Steel was the General Motors of its industry, a company that accounted for nearly 40 percent of all U.S. capacity with assets totaling more than $2 billion. For four decades, U.S. Steel had adhered to a policy that proclaimed it "unalterably opposed to any extension of union labor." What got the meetings with Lewis going and propelled their momentum, scholars agree, was the growing realization of a pragmatic CEO, unremarkable as it may seem, that the face of American industry was changing, and the CIO was the principal engine driving the change. The union victory over GM only speeded up his thought process. Taylor, like everyone else, could see new members rushing to join SWOC. Forty-four days, marked by strife and bloodshed, elapsed before GM signed with the UAW. Maybe the showdown in Flint would prove to be a parlor game compared to what could befall the steel industry, which Lewis had identified as his primary industrial target long before the GM sit-downers caused him to change course. If push came to shove in steel, pessimists foresaw the most savage battle in American labor history.

All the same, the ground rules or the outcome of a steel strike were by no means preordained, as both Taylor and Lewis realized. The situation at U.S. Steel and elsewhere in the industry differed from that of General Motors in several regards. First came the sentiment of the rank and file. Pro-union and anti-company feelings appeared to run higher at GM. Second, UAW partisans had compensated for their lack of numbers at GM by seizing a few key plants that controlled virtually the entire manufacturing cycle. Steel production didn't utilize assembly lines that could be shut down quickly to backlog an entire process. Another dissimilarity concerned the position of competitors. GM's rivals took advantage of its troubles to sell more cars. The AISI was believed to have forged an all-for-one agreement that called for each company to share its profits with any other shut down by a strike. Finally, no one could be sure how state and federal officials would react to a strike against U.S. Steel. The political uncertainty that had influenced Lewis in the Chrysler strike hadn't dissipated. Neither he nor anyone else could use the automobile strikes as a roadmap.

While Lewis had to weigh these factors as he considered how far to bend, Taylor had a singularly compelling reason for making peace: preservation of the lifeblood of any corporation, namely profits. His company already was benefitting from the economic stimulus policy of the Roosevelt administration, and as Europe edged closer to war, the sale of armaments

offered the prospect of additional growth. At that very moment, U.S. Steel was negotiating a lucrative arms deal with the British government that would be negated by a strike. Thus, each man had reasons aplenty to consider as they worked toward the compromise that would avoid a strike and lead to the spectacular announcement on March 2, 1937, that the United States Steel Corporation had signed a contract with the CIO's Steel Workers Organizing Committee.

The agreement was greeted almost universally as another landmark achievement by John L. Lewis and the CIO and a "surrender" or "cave-in" by Myron Taylor and U.S. Steel. Coming only three weeks after the GM-UAW settlement, the U.S. Steel–SWOC pact made the Lewis-CIO juggernaut appear invincible. Looking beyond the general perception, however, it became obvious that the union didn't get everything it sought and, in fact, came away with less than it did from the GM negotiations. Each company agreed to bargain with the CIO union—the UAW and SWOC—but U.S. Steel retained the right to negotiate with other labor groups in the future while Lewis and the CIO abandoned their cherished goal of a closed shop. The steelmaker also agreed to raise its minimum wage to five dollars a day, establish a forty-hour week with time and a half for overtime and instituted a grievance process. Other steel companies immediately adopted the wage and fringe benefit portions of the package in an attempt to lessen the significance of the industry leader becoming the first to enter into an agreement of this kind. In his autobiography, Girdler mentioned Republic's wage increase as if it were a unilateral and possibly altruistic act, devoid of any impetus from the U.S. Steel–SWOC agreement.

Limiting their negotiations to one-on-one gave Lewis and Taylor a big advantage in preserving the secrecy of their historic meetings. Away from the clandestine sessions, Taylor was known to consult with at least two confidants, but Lewis apparently kept his own counsel. His closest aides— even his handpicked director of SWOC and right arm from the UMW, Phil Murray—didn't know what he was up to. After Lewis and Taylor had cut their deal, the CIO chief assembled Murray, union attorney Pressman and garment union leader Sidney Hillman in his New York hotel suite on Sunday morning, March 1. Lewis ran through the terms and told Murray and Pressman to be in Pittsburgh the following morning to sign the agreement in the offices of U.S. Steel. Murray was stunned. The news had to hurt. The Steelworkers Organizing Committee was *his* enterprise, and he was being told to put his name to an agreement into which he'd had zero input. Lee Pressman, at least later on, seemed nonplussed when he was quoted

as saying, "That's his [Lewis's] function, to meet the Myron Taylors and knock down the doors of the mighty citadels of the USA, and then say, 'Now, go down to Pittsburgh and get your contract.'" Murray might sign the agreement, but Lewis let everyone know how the deal had unfolded. In one respect, the chief's solo negotiating act represented a role reversal, if one accepts a critique offered by biographer Wechsler. Lewis was the public face of the CIO and "seldom posed for the cameras" alongside Murray, Hillman and many other top lieutenants who "undertook the laborious assignments and directed vital campaigns, with Lewis often arriving only in time for the triumphant finale."

Historians have joined Pressman in speculating about the aftereffects on Murray's psyche. The SWOC director didn't air his feelings publicly. When Alinsky was preparing his biography of Lewis, the author said he twice wrote to Murray seeking an interview, but both overtures were ignored. "It's the kind of thing a man doesn't talk about, to any intimate," said Pressman. He and others suggested that Lewis's high-handedness left his lieutenant feeling insecure, as if his manhood had been challenged, so much so that he had to do something to prove himself—to his mentor, his union, the world. "The imputation of 'softness' bothers Phil Murray," Vincent D. Sweeney revealed in *The United Steelworkers of America: The First Ten Years*. "But even though Phil Murray lacks the killer instinct, he can make a hard decision when his conscience tells him he must come to it…There finally comes a moment when…[he] cannot be budged." Lewis addressed the tension between him and Murray in an interview with Alinsky long afterward. The CIO chief said the magnitude of the victories at General Motors, Chrysler and U.S. Steel "apparently set a stage for Phil Murray's inner feelings and insecurity whereby he decided he was going out and win a battle all by himself. He also felt…that the CIO was unstoppable and was convinced that the unbroken string of victories, the very momentum of the organizing drive and the psychology of the times would carry him to victory."

Given the CIO's track record, why *wouldn't* Murray, along with a sizeable chunk of the country, feel that the group was unstoppable? The more intriguing question is why Lewis, having tasted monumental, ego-inflating triumphs, opted to sit on the sidelines while Murray and SWOC planned their move against Little Steel. Even in his interview with Alinsky, Lewis remained his enigmatic self. Historians who have scrutinized his every move haven't been able to satisfactorily explain his passivity when SWOC field organizers, themselves feeling pressure from the rank and file, were clamoring to cut Little Steel down a few sizes smaller. About the closest

Lewis came to explaining his thinking was when he told Alinsky, "This was the first time in Murray's life that he acted without requesting my advice. I told him what I thought, and he has never forgotten that." Presumably what Lewis thought was that the strike would fail, for whatever reason, but there is no record of the leader stating that specifically or forbidding the subordinate from going forward.

Lewis may have decided to consolidate his gains instead of taking on a consortium of determined industrialists whose purchases of weapons demonstrated that they literally were preparing for war. Motivated by the U.S. Steel agreement, steelworkers were pouring into SWOC. Biographer Selvin pointed out that by the end of May 1937, SWOC had racked up 142 contract agreements and 370,000 members, but the union couldn't crack four of Little Steel's corporate ranks. The companies would meet with SWOC representatives but refuse to sign agreements. Membership in the CIO was nearing 3.5 million, and his advisers convinced Lewis to swell the rolls further by raiding the rival AFL for more member unions. AFL leader Green complained that "every town and every city, small and great, seems to be filled with…CIO organizers." It's possible that Lewis, weighing these gains against the Little Steel challenge, asked himself, "Why tamper with success at this point?"

The CIO's successes along with its overtures to discontented AFL member unions also brought about "a pronounced shift of Communist unions into the CIO," observed Harvey A. Levenstein in *Communism, Anticommunism and the CIO*. Beginning in April with the Transportation Workers Union and continuing for several months, "most other Communist-led or Communist-influenced unions followed suit." By all accounts, however, Lewis retained full control, and party influence remained minimal. The party had no designs on a takeover of SWOC or any other labor organization, remaining content to work as junior partners as it went about pursuit of its Popular Front, according to Levenstein.

Disagreements within the CIO hierarchy over how to handle the Communists provided more evidence that in the 1930s, the Communist Party of the United States (CPUSA) presented a Rorschach test to anyone trying to understand the labor movement. Rank-and-file steelworkers, many of them Catholic, Southern or Eastern European and socially conservative, wouldn't have dreamed of joining such an atheistic group but gladly welcomed its help to achieve their goal of union recognition and a better standard of living. Key steelworkers organizer George Patterson explained this widely held precept in his unpublished autobiography: "When the helping hand

was offered by any group, it should be taken gratefully, and not cast aside as a spurious, off-hand arrangement of the moment." Police officers, many of them Catholic, Irish and socially conservative, saw the party as an alien force that had duped gullible working-class guys as it sought to impose a godless soviet system. Some cops, as well as others, believed that CIO stood for Communist International Organization.

Tom Girdler and his allies at Little Steel wholeheartedly agreed with the latter view. Girdler admitted that he and "a vast majority of the steel men of the nation" were bitter about U.S. Steel's agreement with SWOC. "Unquestionably many thousands of workmen interpreted the event as a wonderful victory for themselves," the Republic leader conceded. "But I am sure that many thousands of workers were shocked, even horrified by the news...A vast majority of our employees did not belong to CIO and we were not going to force them in against their wishes. We were determined to fight." Girdler said Republic was willing to bargain with the union as long as it didn't have to sign a contract. He cited a 1937 U.S. Supreme Court decision upholding a loophole in the Wagner Act that did "not compel any agreement whatever."

In his autobiography, Girdler went on to relate how a cross section of Republic employees ("not an office man in the lot") paid a supposedly unannounced visit to the offices of company executive Charles M. White in Cleveland. Their message: "If Girdler signs an agreement with the CIO, we strike!" The official assured them of the company's support, the workers pledged to reciprocate and there were handshakes all around.

"Go home and tell the boys Tom Girdler won't sign," said White.

LITTLE STEEL, BIG STRIKE

I n the spring of 1937, it seemed that half the country had recently been on strike, was presently on strike or was planning to go out in the near future. Understandably, most of the national publicity focused on the auto and steel industries, but elsewhere, drugstore clerks in Jersey City; hosiery workers in Reading, Pennsylvania; rubber workers in Akron, Ohio; thread mill employees in Dalton, Georgia; and hundreds of thousands more in myriad industries across the nation took part in the strikes. During the second and third weeks of March, Chicago saw nearly sixty sit-down strikes to go with several conventional walkouts. The number of strikers in each case varied from a half dozen to 5,500, according to a *New York Times* roundup. A strike by taxi drivers represented the largest and most violent of the job actions. Cabs were overturned or burned and strike breakers beaten in the heart of the Loop. In February, workers at the Fansteel Metalurgical Corporation in the town of North Chicago staged a sit-down strike for several days. Police finally used tear gas to rout the occupiers, who not only lost the strike but were also later prosecuted and convicted. Among the arrestees was a SWOC organizer named Joe Weber who would play a pivotal role in the upcoming Republic Steel strike.

The Steelworkers Organizing Committee didn't need to call a strike—yet. Phil Murray's recruiting drive had the fish jumping into the boat, as it were. Six months of canvassing had netted 125,000 members. After another six months, the number had leaped to 200,000. Charles A. Madison wrote in *American Labor Leaders* of union organizers "enrolling tens

of thousands of workers with the zeal and fervor of religious revivalists." SWOC decided early on to go after the company unions, the so-called Employee Representation Plans (ERP), sensing correctly that many of their leaders as well members wanted a legitimate union. The Carnegie-Illinois Company, a U.S. Steel subsidiary, handed SWOC a convenient selling point when it increased its work week from forty-four to forty-eight hours. Only an independent union could have prevented that move, SWOC told the workers, and some three thousand employees at Carnegie-Illinois' South Chicago Works joined the union en masse. Soon afterward, the company agreed to a signed contract.

The first major strike in SWOC's history affected twenty-five thousand workers at Jones & Laughlin's plants in Pittsburgh and Aliquippa, Pennsylvania. The company had cut ties to its ERP but refused to take the next step—negotiate a contract with the union. On May 12, picket lines formed at the mill gates in both cities, but after thirty-six hours, the strike ended. Like U.S. Steel, the company was doing too well to chance a lengthy shutdown. J. & L. agreed to an election supervised by the NLRB, which the union won handily, 17,028 to 7,207, and gained a signed contract. Author Madison quoted one jubilant employee saying, "It's worth twelve dollars a year (in dues) to be able to walk down the main street of Aliquippa, talk to anyone you want about anything you like, and feel that you are a citizen."

SWOC's victory put a serious crack in the ranks of Little Steel, but it would be the last for several years. Republic, Bethlehem, Inland and Youngstown, employing a total of 186,000 workers, dug in. Having tasted success at J. & L., SWOC pushed ahead. On March 31, the Republic office in Cleveland received a mimeographed letter from the union that contained a copy of the Carnegie-Illinois agreement. The company was asked to sign. Of course, Tom Girdler and his organization had no intention of signing, but they did agree to meet with SWOC representatives on May 11 in Cleveland. Prior to the meeting, Republic closed part of a mill in Canton, Ohio, in answer to union organizing efforts there.

Republic stood ready and willing to bargain collectively with the union for those represented by the organization, Girdler stated, but as for signing a contract, well, the company would stand by its position that the Wagner Act, just upheld by the U.S. Supreme Court, required no such thing. The CIO still insisted that Little Steel was defying the intent of Congress and the High Court, but until the court ruled again five years later, Girdler could accurately maintain that "our refusal to sign was upon the highest authority in the land." Three years earlier, the Republic boss had famously declared,

Steelworkers Organize in the Southeast Side

Long hours, low wages, and unfair policies prevailed as the Steel Workers Organizing Committee, or SWOC, reached out to workers in 1936. While US Steel, the industry giant, signed a contract with SWOC in March 1937, other smaller companies or 'Little Steel' refused to recognize the union. On May 26, 1937 workers began a strike against these companies. Tensions mounted as Republic Steel attempted to break the strike. A few days later, on May 30, the Memorial Day Massacre occurred.

Plaque at the base of a memorial sculpture near present-day steelworkers' union headquarters on Chicago's Southeast Side. *Photo by John F. Hogan.*

"Before I spend the rest of my life dealing with John L. Lewis, I'm going to raise apples and potatoes."

Murray, meanwhile, had painted himself into the proverbial corner. He and his associates were left with no alternative to a strike, but they "were not yet strong enough to stand up to the ferocity and coercion of the Little Steel companies," Madison argued. Further, they "had underestimated the blind obstinacy of Girdler and the other executives and had depended on help from the federal government—two bad guesses that soon proved disastrous."

In and around Republic's South Chicago works, both sides readied for action. On the night of May 14, some 350 members of Steelworkers Local 1033, more than half the total membership, met and voted to send a telegram to SWOC authorizing "any decision made…for winning a signed union contract" (i.e., a strike). The meeting was chaired by John Riffe, a jowly thirty-three-year-old former coal miner and UMW organizer from rural Kentucky who commanded about a half dozen other organizers in his capacity as SWOC's sub-district director in South Chicago. As Riffe and his associates awaited the go-ahead from the high command, anticipating a traditional strike, they were unaware that Republic had other ideas in mind—"thinking outside the box," to use a latter-day expression.

The tipoff should have come when the company began moving cots and food into the plant. Everyone understood, not incorrectly, that the accommodations were for the benefit of the plant managers during a strike. What the union didn't realize was that the bosses were going to have lots of friendly company, unlike the situation in Massillon, Ohio, where Republic closed its facility on May 20 in anticipation of a strike.

Three high-ranking police officials visited the plant between May 22 and 26, the day the strike began, to make security arrangements on behalf of non-striking employees. Plant manager James Hyland explained to the first commander to come calling, Captain (and later commissioner) John Prendergast, that the company planned to house non-strikers in a nearly completed wire mill while it kept the entire operation running for the duration of the strike. It may have been at this point that Hyland enlisted the help of the police in executing a clever bit of strategy—ushering strikers and strike sympathizers out of the plant and leaving it totally in the hands of so-called loyal employees. Prendergast, who was chief of the uniformed police, also met with at least ten of Hyland's superintendents, who, according to the captain, expressed unease about the impending strike. On a separate occasion, Hyland received a visit from Captain Thomas Kilroy, commander of the Ninth District, which encompassed the Republic facility.

At some juncture during the visits, arrangements were made for the police to take over a small guardhouse inside the gate for use as a field headquarters. Also at these meetings, it may be assumed that details were worked out for the officers assigned to strike duty to be fed in the plant cafeteria at Republic's expense. Prendergast conceded later that his men may have eaten there on one day, but a civilian eyewitness subsequently testified under oath that he saw policemen eating at the cafeteria every day for a week after the strike started, even after they supposedly had been ordered to stop. A second, much more serious allegation of improper police-company collaboration likely evolved from these visits. The U.S. Senate investigation of the strike concluded that axe-handle clubs and tear gas used by the police against demonstrators on Memorial Day could have come only from Republic Steel.

Charges that the police were both fed and armed by the company stand in contrast to the department's lack of contacts with representatives of the union. The first formal meeting apparently didn't occur until May 28, six days after the first police visit to Republic and two days after the strike began. Then, union representatives went to see Captain Prendergast and Police Commissioner James Allman, not the other way around. Preparations to deal with the strike appeared rather one-sided, to say the least.

A fourth high-ranking police officer who was to play the most decisive role in the coming madness claimed, contrary to other reports, that he didn't meet with Republic officials until the first day of the strike. Captain James Mooney, supervisor of the department's Second and Third Divisions and Kilroy's immediate superior, held primary responsibility for maintaining order around the Republic plant. He was the son-in-law of legendary turn-

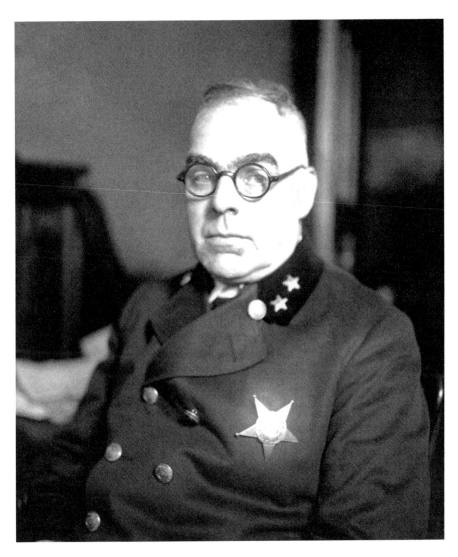

Chicago police captain James Mooney in 1925. Mooney commanded the officers who shot, clubbed and gassed marchers supporting the Republic Steel strike. *Courtesy of the Chicago History Museum DN 0079450.*

of-the-century police superintendent Francis O'Neill. A big, balding man with a long face and dark glasses, Mooney harbored a fear and hatred of Communists and was convinced that "Reds" were instigating the strike. Asked to define a "Red," he said the person was someone "here to undermine the government and assault policemen. It seems to me that murder is just inherent in their nature." Mooney's views, in the words of the Citizens Joint Commission report issued after the strike, "bordered on the pathological." The captain, the group claimed, revealed "his complete ignorance of the radical movement" and that of the issues involved in the strike.

Mooney had revealed an antipathy toward union picketing and leafleting on seven occasions between August 1936 and May 1937. In one of the encounters, officers under the captain's command forcibly dispersed a group of men who were distributing SWOC handbills and newspapers at Carnegie-Illinois' South Chicago plant. Police confiscated some of the literature and turned it over to company security officers.

By the day set for the strike, Wednesday, May 26, everyone concerned— Republic management, pro- and anti-union workers, SWOC leaders, the police—was on edge. The day before, an ominous tone had been set. One striker was fatally shot by police as workers at Republic's Canton, Ohio plant became the first to launch a walkout against the company. Earlier Wednesday, in Dearborn, Michigan, UAW leader Walter Reuther and his top Ford organizer, Richard Frankensteen, were severely beaten as they distributed literature outside a gate of the company's giant Rouge factory. They and other union supporters were

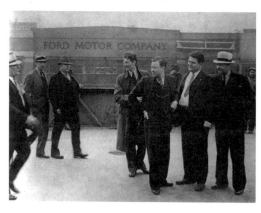

attacked by a group of some fifty Ford workers. Sixteen UAW people, including seven women, were injured. Regardless, Republic's union employees in Chicago were anxious to go out, perhaps too anxious. Strike fever had been spreading through the industry for weeks. Two weeks earlier, twenty-seven thousand Jones & Laughlin employees had gone out, raising to thirty-three thousand the number of workers on strike against the country's smaller steelmakers.

Ford security men confront UAW officers, *left to right*: Robert Kanter, Walter Reuther, Richard Frankensteen and J.J. Kennedy outside the Ford Rouge Plant in Dearborn, Michigan. *Courtesy of the Walter P. Reuther Library, Wayne State University.*

At Aliquippa, Pennsylvania, police hurled tear gas into a throng of five hundred pickets at a J. & L. mill. Six nonunion workers were beaten when they tried to cross picket lines. At least three strikers were injured in battles with the police. Pickets smashed the windows of a U.S. Post Office truck when they erroneously believed the vehicle was carrying food to managers and officeworkers inside the plant.

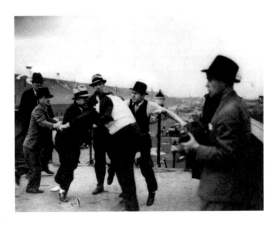

UAW organizer Frankensteen is beaten by Ford security men. The attack is captured by news reporters and photographers to the right of the picture. *Courtesy of the Walter P. Reuther Library, Wayne State University.*

One of the lingering mysteries of the Republic strike is whether or to what extent management contributed to a disorganized, almost haphazard start. Zero hour was set for 11:00 p.m. "This allowed two strong union shifts, the second (three to eleven p.m.) and third (eleven p.m. to seven a.m.)...to meet at the gate and form a strong picket line to meet the first shift, the weakest union shift, on their way to work in the morning," explained William Hal Bork in an unpublished master's degree thesis for the University

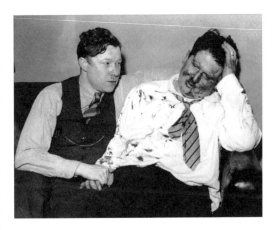

Reuther (left) and Frankensteen following their beating. Their "offense" was distributing UAW leaflets outside the company's Rouge Plant. *Courtesy of the Walter P. Reuther Library, Wayne State University.*

of Illinois–Urbana in 1975. Since the plant had only one gate, it appeared to be an easy task to mass a large number of pickets and keep the first shift from reporting. It seemed like a smart plan, but developments didn't unfold that way. The company was on to the strategy and had developed countermeasures.

The day shift put in a normal day's work on May 26, but apparently according to a prearranged plan, nonunion employees had been told not

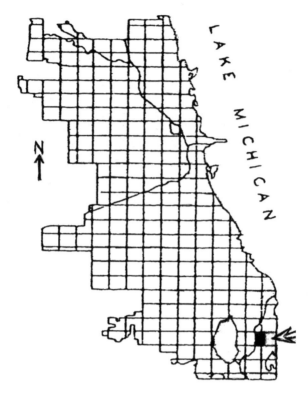

City of Chicago grid showing the location of Republic Steel's South Chicago plant on the far Southeast Side. *Courtesy of Alex A. Burkholder.*

to leave the plant but to go to the wire mill where the cots and food had been brought in. About the same time, workers in the pro-union billet (steel bar) mill, who had just started their three-to-eleven shift, threw down their tools and began to chant, "Strike, strike, strike." They moved through the plant, encouraging others to join them, and eventually assembled a group of 100 to 150 headed for the gate. Scuffles broke out when the strikers encountered workers who declined to join the march. Foremen, who were all too happy to accommodate the exit, encouraged known union men to join in. The straw bosses went through the plant telling workers that the strike was on with the change of shifts. By about 4:00 p.m., a group of several hundred had assembled outside the plant gate at 118th Street and Burley Avenue, leaving a larger number of "loyal" employees inside. Republic had pulled off the equivalent of a reverse sit-down strike, positioning its people inside to run, not shut down, operations while the people whose intent was to shut down operations were left outside, looking in. Whether the early walkout was provoked by the company probably will never be known. One union leader said, "Someone pushed the button (early), I don't know who."

John Riffe got blindsided. He had to be the most surprised person at Eagles Hall, Local 1033's headquarters at 9233 South Houston Avenue. As he chaired a meeting of the night crew, going over final instructions before

The former Eagles Hall at 9233 South Houston Avenue, steelworkers' union headquarters in 1937, stands vacant in 2013. *Photo by John F. Hogan.*

they were due to report, someone came in from the plant about 5:00 p.m. with the news that the strike had started at 3:30 p.m. Riffe was incredulous, reiterating that the strike wasn't supposed to begin until 11:00 p.m. "Well," his informant said, "the bosses and the foremans [*sic*] in the plant came around through the plant telling the men, 'The strike is on at the change of shifts [three p.m.].'"

Riffe adjourned the meeting and headed for the plant with about 200 of the attendees. When he arrived, Riffe said he found at least 150 policemen outside. (More realistic estimates put the number at 60 or 80.) "They were driving up in paddy wagons, in their own cars and assembling under the command of Captain Mooney and Captain Kilroy," strike organizer George Patterson remembered. The officers were responding to a call from plant manager Hyland. Riffe sought out Mooney, who sent him inside the gate along with several policemen to bring out any union people still there. The union leader found several hundred standing in the yard outside one of the mills and told them to come with him and picket outside. Mooney stopped him, apparently thinking that Riffe was trying to entice nonunion men as well. Riffe said he asked the captain, "How do I know our men from the rest

A barbed wire–topped fence and railroad tracks still mark the eastern boundary of the Republic plant site. *Photo by John F. Hogan.*

of them?" Mooney responded with profanity, according to the strike leader, and told him, "We are going to run this plant whether you like it or not." Riffe left after being assured that the strikers could picket as long as they stayed on the other side of the Pennsylvania Railroad tracks that paralleled the facility, about forty yards east of the plant gate.

After Mooney finished with Riffe, something else caused his temper to rise—the now-familiar presence at union rallies of a sound truck. The arrival of the truck, festooned with signs proclaiming, "Forward with the CIO" and operated by union organizer Gene Krzyki, coincided with the departure of union supporters streaming out of the plant. Cheers went up from the swelling crowd as workers emerged in groups of five or six until several hundred joined the picket line forming outside. Krzyki used the loudspeaker to urge others inside to join the ranks. If Mooney agreed even halfway with Tom Girdler's florid description of sound cars, it's little wonder he became unhinged. "Nerve rasping, unhuman, devilishly-inspired, the voice of a contemptuous monster from another world. By a queer perversion of American inventiveness," Girdler concluded, "the sound truck became the voice of the mob."

By now, between five hundred and seven hundred union supporters had gathered in Burley Avenue, beyond the rail tracks boundary established by Captain Mooney. One of the arrivals was Patterson, a thirty-eight-year-old Scottish immigrant who wrote a lengthy, unpublished account of the strike and its aftermath. Patterson was concerned that no picket line had been established immediately outside the plant gate. He expressed his feelings to Riffe, who told him to "set one up, if you can." Patterson mounted the hood of his car and called for volunteers. About two dozen men responded, "and we began a semblance of picketing before the main gate. Some went to another entrance farther down the railroad tracks," (presumably the one used for rail traffic). All the time Krzyki was blaring taunts at the police while encouraging workers inside the plant to come out and join the strike. "You scabs in uniform! Get out of there!" he yelled at the cops. "Get them finks out of the plant!"

Mooney had had enough, even though the main body of pickets hadn't crossed the tracks. He instructed Captain Kilroy to move two platoons totaling sixty-four officers from inside the plant fence to clear Burley Avenue of strikers. Riffe, at the time, was holding a meeting across the street to discuss the next move when he heard a commotion. He saw the policemen, three groups abreast, coming out of the mill gate. Patterson said he and his small band of pickets had been marching for only a few minutes when he noticed Riffe holding a heated discussion with Mooney and Kilroy. "The argument was short," Patterson said, "and the next thing I knew, Riffe was being put into the Black Maria [police wagon]."

Obeying a profane command from Mooney, the officers moved on Krzycki and his sound truck, arresting him and confiscating the vehicle. Patterson and his pickets got the message and started to retreat, but apparently not fast enough. The police drove them north on Burley and east on 117th Street. "They went up on porches," said Patterson, "into the taverns, and into people's gangways between the homes, on to the property, driving everyone away from the Republic gates." Call it bravado or plumb crazy, but Patterson and some of his companions performed their only act of defiance; they sat down in the street. That was when "the cops really went to work," Patterson related. "They had been whacking our behinds to make us move. Now they began to pick us up bodily and actually threw us into the prisoner vans (or "throwed," according to Riffe, who sometimes mangled verb forms). "I landed head first, right onto John Riffe's lap," Patterson continued. "'Welcome, brother,' he said." Before he was tossed into the wagon by Mooney, Riffe said the captain cursed him and called him a Bolshevik.

The twenty-three strikers arrested were taken to the South Chicago police station, where they were charged with disorderly conduct and unlawful assembly and jailed overnight. They were bailed out the next day by SWOC attorneys, pleaded guilty in court and were fined one dollar.

At 11:00 p.m. on Wednesday, when the strike was supposed to have started with a mass picket line outside the Republic gate, the only people left wore blue coats with badges attached. Non-striking night shift workers entered the plant as if nothing had happened. Inside, some of the nonunion workers who had remained settled down for the night on the limited number of cots available in the wire mill. Others passed the night as best they could, with some sleeping on the floor. Day one of the strike had not gone well for the union.

After he got bailed out early Thursday morning, May 27, Riffe said he spent the rest of the day posting bond for his fellow arrestees. It was a day for both sides to retrench. Republic used the time to issue a multipage statement spelling out its position on numerous issues, such as the closed shop ("It denies [the worker's] right to choose what particular union he desires to join—if any.") and the union dues check off ("If [a worker] wants to contribute to a labor union, that's his business…We don't want to be a dues collector for the CIO or any labor union.").

The lull also provided an opportunity to catch up on strike news from elsewhere in the country. In response to Phil Murray's command from Youngstown, Ohio, strikes had been called at twenty-seven steel plants in five states—Illinois, Indiana, Ohio, Pennsylvania and New York. In addition to Republic, Inland and Youngstown Sheet and Tube were the principal targets. The *New York Times* estimated that between seventy-five thousand and eighty thousand employees were "affected" but left unclear how many were actual strikers. At Republic's South Chicago operation, precise figures were difficult to pin down, but best estimates placed the number of strikers at 750 to 800, "loyal" workers inside the plant at 1,000 to 1,100 (Girdler claimed 1,400). Some 200 of these entered after the strike had started. One, apparently wanting to circumvent any confrontation, swam the Calumet River to reach the plant. The remainder of the 2,200-man workforce probably stayed away to avoid potential violence.

Girdler claimed that only a few of the strike participants had ever worked for Republic. "Some were from plants of other steel companies, even from other states." Others were "idlers" who are always on hand for any excitement. Still more, he said, were present "to make trouble, to start fights." There is no question that the Republic people got plenty of outside help, particularly

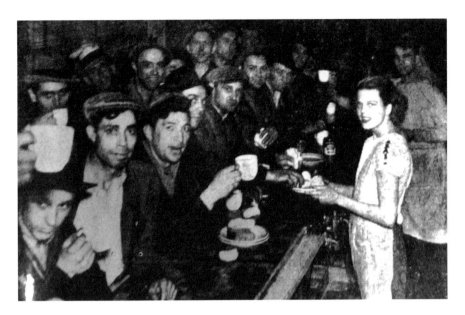

Strikers chow down at Sam's Place prior to Memorial Day. The former tavern at 11317 South Green Bay Avenue served as the union field headquarters. *Courtesy of Local 1033, Steelworkers Organization of Active Retirees (SOAR).*

from the Indiana Harbor area across the state line. As for making trouble and starting fights, the pro-union men were a fairly compliant bunch during the first two days of the strike.

Union pickets were having much greater success at Indiana Harbor, where some 1,500 turned out Wednesday night for the official start of the strike, 11:00 p.m., at both the Inland and Youngstown plants. Police offered no interference. Chicago mayor Kelly indicated that that would be the case going forward at Republic. He issued a statement that peaceful picketing would be allowed in accordance with city statutes. The strikers figured this was their go-ahead to establish a serious picket line outside the plant gate. Captain Mooney either didn't get or heed the message. Only half a dozen pickets were stationed at 117th Street and Green Bay Avenue, well removed from the gate, when word came of the mayor's statement. Two hundred to three hundred strikers had gathered at their rented field headquarters, a former tavern and dance hall called Sam's Place, on Green Bay between 113th and 114th. Buoyed by the mayor's statement, the crowd at Sam's made the three-block walk to 117th and Green Bay to reinforce the six pickets allowed there by Captain Mooney and move the line closer to the gate. Even that small number found itself constrained. Riffe said the police laid down

strict guidelines that required pickets to march in a circle, not stop, remain silent at all times and have each person carry a sign. When the additional troops arrived, they again were turned back by the police and retreated without incident. SWOC leaders told them not to try again until they could learn what, if anything, Mayor Kelly's announcement meant.

The following day, Friday, May 28, Local 1033 president Gus Yuratovac sought out Captain Mooney to obtain some clarification. Mooney told him they could have sixteen pickets. When Yuratovac asked the captain to put it in writing, he was referred to the corporation counsel's office. While the local chief was meeting with Mooney, a pair of union attorneys went to see Commissioner Allman, who told them, "I don't care how many [pickets] you have. You can have one hundred as far as I am concerned as long as they are peaceful...I have no right to tell them how many pickets they may have." Mooney said later he understood his boss to mean that pickets were to be limited to one hundred, not that the union could have as many as it wanted. Increasingly restive steelworkers met Friday on both sides of the state line. At Local 1033 headquarters on South Houston, speaker after speaker denounced Republic, its "loyal" employees and the police. In East

A pleasant residential setting has supplanted Sam's Place, a hotbed of strike activity in May 1937. *Photo by John F. Hogan.*

Chicago, Indiana, speakers exhorted union sympathizers attending a mass meeting to join in a great demonstration against Republic's Chicago plant.

"We'll close that plant down!" thundered South Chicago meeting chairman Joe Germano. He didn't explain how the strikers planned to deal with the dozens of police guarding the facility or the thousand or so anti-union workers inside. It was the first indication that the union was considering some sort of action against the plant. Company public relations people, meantime, took news photographers on a tour to show that the plant was, in fact, making steel and that upward of one thousand men were working, eating and sleeping there. Food from grocers, baked goods from home, dishes and utensils, tobacco, clean clothing, games, musical instruments and, yes, "an occasional surreptitious bottle," to use Girdler's words, were brought in to make life a little more comfortable. Cooperative members of the police detail lent a helping hand with the unloading. There were amateur vaudeville performances and ballgames in the yard. Descriptions of the camaraderie were reminiscent of the GM sit-down strike.

About 5:00 p.m. on Friday, between three hundred and four hundred union supporters regrouped at Sam's Place and decided to stage another march on the plant. In a sequence that would be repeated Sunday, someone in the crowd made a motion to that effect. Patterson wrote that Louis Selenik, a Republic crane operator and strike committee member, hoisted an American flag and people fell in behind him, heading south on Green Bay from 114th Street, toward the plant at 118th and Burley. (Labor historian William Adelman identified the flag carrier as a striker named Esposito.) Some carried CIO banners. The marchers stayed to each side of the street to let auto traffic pass. Captain Kilroy, who was not present, said in his report to Commissioner Allman that about twelve officers were dispatched in response to a report that "an unruly mob" of several hundred "led by a woman in red" (probably Lucille Koch, wife of a union leader) was approaching the plant. The police were under orders, Kilroy said, to turn back the crowd in a peaceful manner. As they neared the small police detachment, the marchers demanded the right to picket. Four policemen, including at least one sergeant, met the leaders at 116th and Burley, two blocks from the gate, and asked them to withdraw. The marchers refused, reminding the police that the mayor had just declared peaceful picketing allowable.

The crowd continued to move forward as the officers, outnumbered about twenty-five to one, gave ground. Near 117th Street, the first reinforcements arrived, twenty-four men who had been stationed inside the gate. Their presence helped stiffen the police line, and the order came to raise batons.

"They told us to disperse or else," Patterson recalled. "We refused, and the next thing we knew, our heads were being clubbed." The *Chicago Tribune* and the *New York Times* agreed that one of the first blows was struck by the flag-bearer who brought the pole down on the head of Officer Edward Opfer. Fellow policemen clubbed the attacker to the ground. It was "necessary for the officers to wield their batons for their own protection," reported Kilroy, who said the crowd was pushing, shoving and throwing rocks. Forty-five more police reinforcements arrived, increasing the size of the contingent to about eighty. Undeterred, those in the front ranks of the marchers directed blows and kicks at the men blocking their advance along the street. One officer got kicked in the groin. He was among six policemen injured along with fifteen strikers. The most seriously injured marcher was Ben Mitckess, a Youngstown Sheet and Tube machinist from East Chicago, Indiana, identified by police as one of the leaders. Mitckess claimed he was singled out by police, beaten unconscious and found himself in a patrol wagon with a number of others, all bleeding profusely. One policeman "stated that I had a Communist face," said Mitckess, who remained in Bridewell (jail) Hospital until the following Tuesday. Of the two other marchers who landed in the hospital, one was also a Youngstown employee, the other a local Republic worker.

Acting without orders, some officers drew their revolvers, and three shots were fired into the air. "I could smell gunpowder all around," Patterson said. "Heads were bleeding and our flags were torn from our hands, some workers, like myself, were fleeing the police in fear…But when we finally stopped…we had some broken heads, lots of blood, much foul language, and a verbal battle with the officers."

The police had won. First the front rank, then the remainder of the crowd broke and returned to Sam's Place, carrying the injured with them. Bloodied but not defeated, the strikers swore "that we would finally, and soon, set up our picket lines," Patterson stated. Then he offered a fateful observation: "None had been shot, so we concluded that blank bullets had been fired to scare us."

Looking back on the skirmish, it's tempting to ask what would have happened if it hadn't occurred. Would the following Sunday have turned out the way it did? The pride and bodies of both strikers and police officers had taken a beating near the same ground where they would meet less than forty-eight hours later. Cops and steelworkers are proud, tough individuals, not likely to forgive or forget blows to the head, kicks to the groin or vile insults. No one can know the depth of the grudges, the desire for revenge,

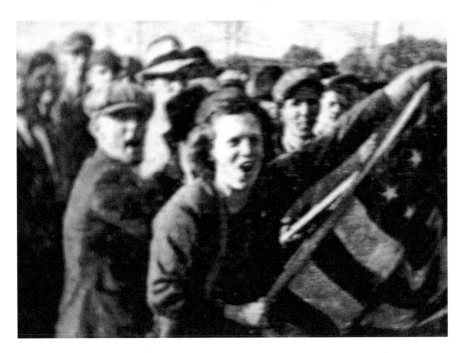

Lucille Koch, wife of a Republic strike leader, displays the fallen flag reclaimed by strikers after their May 28 clash with police. *Courtesy of Local 1033, SOAR.*

the urge to show those bastards the next time. Each side had another day to sort out their emotions.

Outwardly, Saturday, May 29, appeared quiet, but behind the scenes, union organizers were working hard to stage a rally that would top anything they had put together thus far. Apparently the idea for a mass meeting Sunday at 113th and Green Bay surfaced during a meeting the night before at Eagles Hall, not long after the battered marchers had straggled back to Sam's Place. Without much fanfare, three union heavyweights emerged who would play critical roles. They were Nicholas Fontecchio, chief SWOC organizer for the Calumet Region and a thirty-five-year veteran mine workers representative; Leo Krzycki, Polish-born Socialist Party leader, former alderman and undersheriff in Milwaukee and now second-in-command of SWOC's Great Lakes region; and Joe Weber, well-traveled SWOC field representative who was arrested and jailed at the Fansteel sit-down strike in North Chicago. Before joining SWOC in August 1936, he worked as a tool and die maker at Ingersoll Steel in Chicago. A tall, lanky blond with a toothy grin, the thirty-three-year-old Weber also went by the names Roy Hudson and B.K. Gebert, as well as Judson, Ray and Ross, said Max M. Kampelman, author of *The*

Communist Party and the CIO: A Study in Power Politics. Kampelman said Weber's original name probably was Joseph Ruic. The SWOC leader testified under oath that he was born in San Francisco, but his real birthplace was thought to be somewhere in the Balkans. The U.S. government tried unsuccessfully to deport him after World War II, according to labor historian Bork. Philip Taft, author of *Organized Labor in American History*, said Weber was identified as a Communist in a list of organizers maintained by SWOC for its own records, one of seventy-five party members so named. "Since the list was used for administrative purposes, its authenticity does not appear to be in question," wrote Taft, who described Weber as "a leading spokesman for Communist trade union policy."

Following up on Friday night's open meeting, Fontecchio and Weber convened a closed session of a dozen members of the twenty-man strike committee on Saturday morning at Eagles Hall. Fontecchio finalized plans for a mass gathering at 3:00 p.m. the following day, Memorial Day, at Sam's Place. Supporters would be invited to enjoy a family-style picnic, a holiday outing, as they showed their support for the union cause. Fontecchio, Weber and Krzycki would address the crowd with Weber acting as chairman. Although the organizers later denied preplanning, the meeting was to be followed by a parade to the plant gate to finally establish a substantial picket line. Contrary to assertions by police officials, there apparently was no discussion at this point of plans to force entry into the plant and occupy parts of it. The *Chicago Daily News* reported that "hotter heads among the strikers were calling for retaliation" against the police and "Republic servicemen" (security forces) for the clash the previous day, although no Republic enforcers had fought alongside the police.

The man who reportedly carried the American flag at Friday's altercation, Republic crane operator and strike committee member Louis Selenik, remembered the Saturday morning meeting quite differently than did Riffe and Weber. In custody after the Memorial Day clash, Selenik admitted under questioning that strategists had planned "to use camouflaged picket banners as clubs to break through [police] lines." He said Weber told the meeting, "If we marched out there peacefully and didn't have anything, we'd take an awful beating…You have as much right to club as the police, to protect yourselves." Selenik said Weber emphatically ruled out the use of firearms. "But the prairie [next to the plant] was full of rocks and bottles," the crane man added. Each Saturday attendee was to appoint five captains who, in turn, would direct a group of pickets to break through the police and establish a strong picket line at the plant gate, Selenik stated. By now, it

had become clear that Weber, not Riffe, was running the show, taking over either at the latter's request or, more likely, because of SWOC leadership's displeasure with Riffe's performance. Riffe denied a Selenik statement that he had openly criticized Weber's tactics.

Selenik's comments were made to Assistant Cook County State's Attorney (and later federal district court judge) Alexander Napoli while in police custody for nearly a week. Six weeks later, during the coroner's inquest, Napoli walked the strike leader through his transcribed statements. As the county attorney read portions of the transcript, witness Selenik suggested that he may have been "mixed up." He flatly denied saying that the strikers' intent "was to get through to the plant at any cost." Further denials came from Weber, who said that neither he nor anyone else at the strategy meeting made the statements that Selenik attributed to them.

While he was being held at the Burnside District police headquarters, Selenik was questioned by Captains Mooney and Prendergast in addition to Napoli. In return for his cooperation, he said Mooney promised to deliver a Republic paycheck he was owed and get him a job at a Republic location far from Chicago. Napoli had the prisoner taken to the Criminal Court building at Twenty-sixth Street and California Avenue on the near Southwest Side and saw that he was provided with food, coffee and cigarettes in a witness room nicknamed "the stool pigeon's paradise." The crane operator said his questioners seemed intent on getting him to admit that Communists were influencing the Republic strike and that Weber and Patterson were Communists, both premises that Selenik said he refused to acknowledge.

Louis Selenik was released from custody after he signed the statement. A few months later, his body was found floating in Lake Michigan. The circumstances of his death were never determined.

Selenik's close friend George Patterson didn't attend the Saturday strategy meeting because he'd been assigned to go to a lumberyard and then to a sign painting company, to get placards made for the rally the following day. He also was instructed to order loudspeakers and a flatbed truck that would be used as a speakers' platform.

Strike organizers must have been anticipating trouble as early as Thursday morning, May 27, when they retained the services of Dr. Lawrence Jacques, a Hyde Park physician, "to render medical assistance in the strike situation," as the doctor put it, a polite way of saying to treat strikers clubbed by the police. Soon after accepting the assignment, the doctor telephoned his friend, lawyer and patient, Leon Des Pres, then a young labor attorney and

later an independent Chicago alderman and outspoken critic of Mayor Richard J. Daley. "The union had told him…that the police might be brutal with their clubs on peaceful pickets," Des Pres recalled, "and asked him to man a first aid station. He assented, then called me to make sure he could get me if he needed me for anything such as an arrest." Much has been made of the fact that the union reached out to Dr. Jacques before the Memorial Day encounter, evidence, the police and their supporters claimed, that the strikers had something more in mind than a peaceful parade. Less has been said about the doctor also being available to the union prior to *Friday night's* march and subsequent battle, raising similar questions about the organizers' planning process. Dr. Jacques, who treated injured marchers Friday evening at Sam's Place, made a puzzling comment when he appeared before the La Follette subcommittee. He claimed to have learned about Sunday's mass gathering from the newspaper and attended as "an observer" in the

Dr. Lawrence Jacques, the Hyde Park physician retained by the union to treat any demonstrators injured by the police. He found himself overwhelmed. *Courtesy of Local 1033, SOAR.*

event his services might be required. The doctor mentioned nothing about being hired by SWOC to run a first aid station, which he found supplemented by two additional physicians, a nurse and pseudo-medical cars displaying Red Cross signs.

Local 1033's strike committee sent out word to other locals asking for supporters to attend the Memorial Day event. Enthusiasm greeted the invitation at Indiana Harbor, where the strike against Inland was going smoothly and bodies could be spared to give the Republic effort a much-needed boost. An estimated 150 Indiana Harbor volunteers, some who worked the Inland picket lines Saturday night,

would turn out for Sunday's demonstration at Republic. Pamphlets were circulated at Carnegie-Illinois' South Chicago works announcing a mass protest against the actions of the police on Friday.

Organizers of the event strove mightily to leave the impression that the 3:00 p.m. gathering at Sam's Place was called solely as a protest against police interference with lawful picketing and that the subsequent march to the plant was purely spontaneous. This scenario was even a bit too much for the Senate subcommittee, which generally sided with the strikers' version of events. The panel's report concluded, "It was anticipated by many that some form of action would follow the meeting itself, and that a further encounter with the police was not improbable." As evidence of preplanning for something further, the report cited the use of "placards affixed to sticks...designed to be carried in a parade," as well as the presence of Dr. Jacques and cars displaying "crude red-cross signs." Captain Mooney stated that he received information Saturday evening from four anonymous sources that the strikers were planning "to march into the plant." He responded by ordering Sunday's 4:00-to-12:00 shift to report at 3:00 p.m. and the day shift to remain on duty. This change, along with the deployment of a reserve force, would bring the number of policemen on duty to 264.

A number of people who attended the gathering at Sam's Place spoke of a festive atmosphere, a family-style celebration, a picnic in the park for men, women and children—in short, the opposite of an angry protest demonstration. Many, probably most, came with no expectation of what would follow the speeches. Otherwise, why would men bring their wives and parents their children? They were anticipating a friendly get-together to aid a good cause. Others in the crowd, if not there looking for trouble, certainly came prepared for it. Tom Girdler and fellow skeptics believed the rally organizers purposely encouraged the inclusion of women and children to provide cover—"props," to use Girdler's term—for those bent on clashing with the police.

CHAPTER 7
"HERE THEY COME!"

The barren expanse east of the Republic Steel plant between 116th and 118th Streets hardly offered a welcoming site for a Memorial Day outing, even without the presence of police officers armed with regulation .38-caliber revolvers and nightsticks and, in some cases, decidedly non-regulation axe handle–like clubs obtained from company security. Flat prairieland, made grimy by years of smoke and cinder emissions belching from furnaces, was once a river marsh and remained spongy in many places. The total 274-acre company site was bounded by the Calumet River on the west, approximately 115th Street to the north, low prairieland to the south and, in close parallel succession, a barbed wire–topped fence, the Pennsylvania Railroad tracks and Burley Avenue to the east. Immediately inside a break in the fence at 118th Street stood the twenty-five-foot gate that guarded the only pedestrian entrance point. A streetcar line that ran down the middle of unpaved 118th deposited many of the employees here. Another gate at the northern end allowed for the passage of railcars.

Beyond the fence, some twenty individual mills and furnaces extended north–south between the embrace of river and barbed wire. Scattered north and east of the plant enclosure were a few houses, stores, taverns and small truck gardens. Sam's Place, the former bar and dance hall the union was renting, was located about two blocks east and four and a half blocks north of the plant gate. The distance could be shaved by following an old dirt path that ran roughly diagonally across the prairie, from gate to pub, a trail well trod in bygone years by steelworkers seeking the most direct route to after-shift refreshment. The

Tough times hit the steel industry in the 1970s. Once employing 2,200 workers, the Republic plant in South Chicago has stood idle since August 2002. *Photo by John F. Hogan.*

In 1984, Republic merged with a subsidiary of LTV Corporation to form LTV Steel. LTV Steel filed for Chapter 11 bankruptcy in December 2001. *Photo by John F. Hogan.*

marchers who stepped off from Sam's Friday evening, May 28, and followed Green Bay south were turned back by club-wielding police before they could reach their destination. Perhaps strike organizers thought they could change their luck by trying a different route on Sunday.

Even before anything happened, May 30, 1937, stood out as unusual. The calendar showed spring, but the temperature was on its way to eighty-eight degrees, the first genuinely hot day following a long damp spell. Conditions were perfect to lure people out of their houses to see what this union gathering was all about. Church bells across South Chicago, the East Side and Hegewisch summoned the faithful under sunny skies. Afterward, there would be plenty of time for relaxation, picnics, baseball, maybe a trip to the lakefront or a visit to the cemetery on what used to be called Decoration Day, a time for placing flowers and little American flags at the graves of America's war dead. Some might choose to combine their picnics with the labor rally.

The men camped inside the Republic plant weren't going anywhere. Being Sunday, some of the operations, such as three of the eight open hearth furnaces, were down, requiring only a few hundred of the "loyal" workers to keep the round-the-clock processes humming. Those with time on their hands found a number of ways to cope with the voluntary confinement. Catholic and Protestant church services were held inside the plant. In back of one of the mills, near the riverbank, two teams of off-duty men played baseball on a diamond that didn't exist before the encampment. They used equipment brought in from the outside. Most of their co-workers who weren't sleeping turned out to cheer the action. A smaller number who wanted only to catch up on their rest took turns sleeping on the imported cots, the numbers of which still were insufficient to accommodate everyone. Plant manager Hyland was one of those who slept on the floor. Elsewhere, workers played cards, dominoes, ping-pong or musical instruments.

Had the strikers been able to establish mass picketing, it's highly unlikely that this scenario would have been allowed to develop, at least without considerable bloodshed. Pickets at the Republic plant in Youngstown, Ohio, where the authorities had taken a much more permissive stance, were maintaining a virtual stranglehold. Airdrops of food and supplies to "loyal" workers inside had to be suspended after sniper fire made them too dangerous. In South Chicago, 118 policemen stationed outside the gate made sure deliveries went through.

Police protection and creature comforts, such as they were, couldn't dispel the tension that pervaded the plant. Concern existed over reports that

strikers were threatening the families of the men inside. Police received eight complaints of intimidation, made one arrest and assured wives and children of protection. All the men in the plant waited for the assault they'd been warned to expect.

Give the strike organizing committee credit for one accomplishment: they turned out a diverse crowd estimated between 1,000 and 2,500 in less than thirty-six hours. Their telephone tree must have been buzzing. Rally organizers sought to sprinkle the ranks of steelworkers with observers, particularly ministers, students and social activists, whom they believed would provide sympathetic accounts, if and when more trouble with the police developed. For example, Clayton Gill, a student at the Chicago Theological Seminary in Hyde Park, got a phone call from minister and South Chicago social worker Reverend Raymond Sanford who asked him and some classmates to act as observers at a demonstration by strikers. Gill, two other young men and three young women accepted the invitation and together rode public transportation to the site. "I saw clubs and small rocks [in the hands of strikers]," Gill stated, but no other weapons.

After recruiting the young seminarian and others to attend the rally, strike sympathizers made sure their stories got told. Gill's deposition was taken and notarized by Leon Des Pres, who said his lawyer group sought out witnesses the union had missed. Some of the details weren't necessarily what the union wanted discussed. One of Gill's companions, Marilee Kone, also told of seeing participants carrying short sticks and one woman with a handful of rocks. Kone estimated that women and children made up about 10 percent of the crowd. Another witness placed the number of women, excluding children, at more than 10 percent.

Students at the exclusive Francis Parker School in the city's tony Lincoln Park neighborhood were drawn to the demonstration in much the same way as their counterparts at the seminary. Jean Carleton Carey said she was in history class when the teacher, Mr. Mitchell, announced that he was going and invited his students to join him. Carey said she agreed to go out of curiosity but emphasized that she held no strong feelings about the union movement or any of the issues. She and five other students, a boy and four girls, accompanied Mitchell, another male teacher and their wives on both Saturday and Sunday. The wives, who appeared to be involved in meeting preparations, remained overnight at Sam's Place, which came equipped with a kitchen and a room that could be used for sleeping. They were rejoined by their husbands and the students about 1:30 p.m. on Sunday, an hour and a half before the scheduled start of the meeting.

Carey said she spent most of her time Sunday, including the period when the speeches were made, inside the building, helping to pass out water and chatting with attendees. She noted that nothing but water was available from the long bar. At the coroner's inquest some six weeks later, she was asked whether anyone in the crowd that was assembling told her what they planned to do.

"They were going to try to get to the mill and get inside...and get the men out, I imagine," she answered. "They all seemed to think if they got out there and went down there, they could get them out by force."

Carey mentioned seeing men inside Sam's Place holding clubs, baseball bats, hoses, iron pipes and, in three instances, guns. She said she told Emil Koch, chairman of Local 1033's strike committee, "This does not seem to me as if you plan to do peaceful picketing. He said, 'Oh, if the cops get tough with us, we will get tough with them.'"

"Certainly if these men wanted to picket peacefully," she concluded, "they didn't have to carry all these guns and lead pipes and things...They had pieces of trees and they had a broom handle that was sharpened to a point." Carey estimated that "most" of the several hundred people who had gathered by that time had these types of weapons.

At the inquest, the nineteen-year-old woman, who had since graduated from high school, fielded questions from an assistant state's attorney about Communist participation in the strike. In response to one query, she replied that "there was a general feeling in the school" that her teacher, Mr. Mitchell, was a Communist. She stated that he was "put out" of another private North Side school "for teaching Communism." Soon after the recent school term had ended, she added, Mitchell went to Russia and to her knowledge was still there.

Additional observers who turned up included Frank W. McCulloch, an attorney with the social justice arm of the Congregational Christian Churches of America and Reverend Chester B. Fisk, a Congregationalist minister from the South Shore neighborhood, a few miles north of Republic Steel. Reverend Fisk, like seminary student Clayton Gill and presumably others, got a phone call from Reverend Raymond Sanford. Actually, Sanford told Fisk he was trying to reach Fisk's father-in-law, a doctor, but as long as he had the other minister on the line, how would he like to attend the mass meeting as an "impartial observer"? Fisk said he accepted the invitation because "there are quite a number of us in Chicago" who are concerned about strikes and the denial of civil liberties.

Both McCulloch and Fisk would present testimony to the La Follette subcommittee that strongly supported the marchers. In an apparent

move to undercut McCulloch, a police department affidavit filed with the subcommittee claimed that he, along with George Patterson and writer Meyer Levin, were contributors to the *Daily Worker*, the Communist Party newspaper. The subcommittee rejected the affidavit on the grounds that it was too vague.

A chemist named Paul Tucker, also known as Paul Lusker and Paul Bornstein, claimed that his decision to attend the demonstration was spur of the moment. "A fellow [he knew] from Brookfield" came by Tucker's West Side house on Sunday and invited him to come along to a "parade" at Republic Steel, more than twenty miles away and farther still from suburban Brookfield. "I thought the men had a right to picket and to put on a march," he said, so he and his friend drove off to the other side of the city. It's interesting that he spoke of going to a "parade" or a "march" long before the "spontaneous" decision to march was made. Tucker, who'd been arrested four years earlier at a Communist-led demonstration, said, "The men from the union seemed to have everything arranged." His deposition was taken by Ben Meyers, identified by Des Pres as "the regular attorney for the Communist Party."

By Sunday, nothing had happened in the vicinity of the Republic plant to remotely suggest the need for National Guard troops. But that didn't mean the Guard wasn't paying attention. On Saturday and Sunday, in Indiana Harbor and on Chicago's East Side, a Guard officer was working undercover, posing alternately as an independent writer, casual spectator or, at meetings where the press wasn't permitted, a strike sympathizer. The officer had been assigned to make a confidential report of his observations and take photos as part of the Guard's Emergency Plan for Domestic Disturbances. His findings, consisting of nine written pages and thirty-six pictures, were intended as a guide for commanding officers in the event troops had to be dispatched. The undercover officer's identity was never disclosed, even to Senate investigators, a rebuff that Senator La Follette seemed to take as a personal snub. The senator refused to accept the report as evidence, citing its anonymity. "Those engaged in public service welcome public scrutiny," La Follette declared rather dubiously. The senator, however, apparently wanted to have it both ways. While refusing to admit the report as evidence, he sought to make it public over the objections of the City of Chicago and the commander of the National Guard, General Roy D. Keehn. The City and the Guard couldn't object, La Follette maintained, to the public's right to know "all the facts and circumstances" surrounding the events of Memorial Day 1937.

The identity of the military observer remained buried in the files of the Illinois National Guard in Springfield for seventy-six years. Then, in June 2013, in response to an inquiry from the author of this book, a Guard spokesperson identified the undercover officer as Captain Harold H. Cartwright of west suburban River Forest, a member of the Sixty-sixth Infantry Brigade. Cartwright was ordered to start his mission by General Thomas S. Hammond on May 29 and began immediately by checking out strike conditions that night in Indiana Harbor. Cartwright operated alone, but until the Guard opened its files, it was not known that he was succeeded by at least *five additional* officer/agents after his brief assignment ended on June 5. Like Cartwright, each man took a short turn reporting daily on conditions—now thoroughly peaceful—through at least mid-July. The Guard's high command wanted to end the mission in late June, but a cautious Governor Henry Horner insisted that one man continue to be kept on duty.

Without realizing it, George Patterson may have rubbed shoulders with Captain Cartwright that Sunday afternoon. Noticing many faces he didn't recognize, Patterson said he wondered, "How many might be police spies and detectives? Would there be any around to start a disturbance? No, I thought they all look like plain, ordinary steelworkers to me."

Patterson and a friend spent most of Saturday night nailing picket signs to poles. On Sunday, he took the signs to Sam's Place, arriving about 8:00 a.m. to find the flatbed truck already parked out front and the loudspeakers being put in place. The truck would be covered by a canopy and the side of the vehicle facing the crowd festooned with red, white and blue bunting. Weber, who was supervising the work, told him that Kryzcki and Fontecchio would be the speakers with him, Weber, chairing the meeting. Patterson wondered why Van Bittner, who outranked the others in the SWOC chain of command, wasn't the main speaker but said he quickly realized, "Bittner would have been a damper at this type of meeting, with his church-like approach to a very necessary agitational arousal."

Everything seemed in order. By 2:00 p.m., a jovial crowd had begun to form. An absence of tension prevailed. One participant said people seemed "a little dressed up for Memorial Day." Photos show men wearing suits, ties and fedoras, along with women in nice dresses. Some spread blankets and opened picnic lunches. Children darted among the adults playing tag. Patterson was feeling good about the day until "one jarring note" appeared—a woman in a nurse's uniform. He recognized her as the wife of Meyer Levin, the author who had been covering the strike as a sympathetic freelance writer. Patterson asked her why she was dressed that way. "She

said she had come as an assistant to Dr. Jacques, in case that anyone got hurt, that this was a large meeting, and the police action of Wednesday and Friday nights sort [of] forewarned trouble might lie ahead." Patterson said he brushed off the statement. "There will be no trouble as far as I am concerned," he told the nurse.

Rousing, inspirational, mocking, comical—any of these adjectives could describe the remarks made by Weber, Kyrzcki or Fontecchio, but with the notable exception of Captain Mooney (who wasn't present), no one said the speakers urged the crowd "to go through the police lines." Mooney was flat-out wrong when he made that statement to the Senate Post Office Committee on June 24. And not even the captain claimed that the men on the flatbed truck incited members of the audience to attack the police or damage company property. Krzycki, in fact, played the comedian part of the time, telling the crowd they looked healthy from being out in the sun, healthier than they had looked when working in the mills. Some of them, he said, looked almost as if they had visited their neighbors' cellars. Then he turned serious and spoke of having to kneel down and pick up crumbs from the employer's table. Organize and support the CIO, he urged.

Fontecchio drew on his three-plus decades as a mine workers' organizer to tell how the men endured shootings, beatings and jailings before they won contracts that gave them wage increases and procedures for settling grievances. At the same time, he blasted the police, especially for the way they had handled Friday evening's march. He said there were only two hundred men inside the plant, burning tar paper to send smoke up the stacks so it would appear their numbers were greater. Fontecchio implored the crowd to march on the plant and "tell those men working in there to come out." Mayor Kelly and State's Attorney Courtney "are the biggest rats of all," he shouted. It was an impolitic, not to mention impolite, remark about the mayor who had just announced that peaceful picketing would be allowed. In case anyone had forgotten, some of Patterson's placards called attention to Kelly's statement.

"During Mr. Fontecchio's speech," Captain Cartwright, the National Guard observer, noted, "men whom I had seen the night before while visiting the Indiana Harbor picket lines were carrying clubs and going through the crowd in two files." In his written report, this statement by the officer was the first sentence that appeared under the heading: "Evidence of Prearranged Plan to Riot."

Also listening to the speeches, camera in hand, was *Chicago Tribune* photographer Harold Revoir. "One of the strikers walked up to me," said

Revoir, "and he had a large club…that he had been whittling the end of, so it would fit more snugly in his hand. He told me, 'You will get a lot of action pictures today.'" Revoir said another man with a club or pipe told him, "We are really going to town this afternoon."

When Fontecchio finished, he turned the microphone back to Weber, who presented two resolutions to the crowd—one addressed to Governor Henry Horner, demanding the recall of the police from the plant, the other asking support of the La Follette subcommittee. Both were adopted by acclamation. Then, as if on cue, a man in the crowd shouted, "I move we march on the Republic picket line!" With some strike leaders looking down from the roof of Sam's Place, the throng again roared its approval. While none of the speakers urged violence, their "gestures, mannerisms and inflections of voice were calculated to be inflammatory," said assistant corporation counsel William V. Daly, who was not present.

Before the proceedings concluded, a large column of men already was forming on Green Bay between 113th and 114th Streets. Someone shouted, "All Indiana Harbor men, fall in!" George Duncan Bauman, a reporter for the *Chicago Herald and Examiner*, identified four lines, each numbering about twenty-five men, who were within earshot of the speakers but paid no attention to them. The alignment, said Bauman, "apparently was pre-arranged, and they were following definite orders and had a definite purpose of their own." The reporter said he expected trouble "because of the temper of the people."

Bauman's colleague at the *Tribune*, Edwin J. Kennedy, estimated that within ten minutes, two hundred to three hundred people lined up on Green Bay, four abreast, in company formation. He said they carried clubs, iron bars, bricks and slingshots containing iron bolts. Kennedy said he overheard statements that it would be "too bad for any coppers that got in front of them," that the marchers needed to go through the police lines, into the plant, and "run those scabs out of there."

Another who could hear voices from the formation, a nineteen-year-old ice cream truck vendor named Clyde James, stated that he heard one man tell another, "I have my gat loaded" as he patted the back pocket of his trousers. James said he saw some men tear down a fence near Sam's Place and use the wood for clubs.

Back at the meeting, Weber called for two American flags to be brought toward the speakers' platform. Two young Republic strikers, John Lotito and Max Guzman, carried the flags forward. Weber directed the flag-bearers to the head of the column and urged everyone to line up and march on the

plant. Hundreds complied, but others plainly had reservations. Those who didn't have clubs in their hands, the Guard officer noted, were somewhat surprised by the serious tone the gathering was taking. Some returned to their cars or to family members who had remained in the background.

With the oratory ringing in his ears, Patterson was feeling upbeat. "It was a rare group on the stage," he recalled, "the performance good, and the people in the mood for a march and a challenge. Did they not have Mayor Kelly's word again that they could picket?" As he passed out his picket signs, his enthusiasm began to fade. He looked around for organizers to lead the march and found none. When Weber left the platform, Patterson asked him if he were going to lead. Weber replied that he'd been assigned by Fontecchio to keep the Eagles Hall office open. Fontecchio and Kryzcki also were headed there, all three ostensibly to prepare for a speech by Bittner. "I next saw Hank Johnson and asked him [to lead]," Patterson continued. "Again came an excuse that he had a meeting to go to." Patterson was struck by the realization that the three men who had set the march on Republic in motion, plus one other strike leader, were headed in the opposite direction. John Riffe participated, but he led from behind, far back in the ranks.

Growing frustrated, Patterson said to no one in particular, "Someone has to go with these men and meet the police." He said a voice replied, "Why don't you?" That was how George Patterson found himself at the head of the column along with the flag-bearers; his friend and fellow Scottish immigrant Jim Stewart, president of Local 65 at Carnegie-Illinois; Louis Calvano of Wilson Steel; SWOC organizer Harry Harper; Inland rigger Hilding Anderson; social worker Lupe Marshall; and a couple additional union men. Stewart carried a placard that read, "Bullets and Batons instead of Protection at Republic Steel." They headed south on Green Bay toward the point where the street met the dirt path across the prairie. The leaders were followed by about one thousand marchers as the improvised medical cars pulled onto the field. A number of young women moved to the front, following the lead of Lupe Marshall. The National Guard officer said they carried sticks and clubs. He also observed women carrying children and entire families, but hundreds of people who had attended the rally stayed behind. Halfway across the field, he stated, a man was issuing flagstones that "had recently been placed in a pile," as if it were an ammunition dump. Another witness told of seeing men earlier unloading the stones from a truck. Some marchers wound up with a rock in one hand and a club in the other, the officer said.

Moving toward their confrontation with the police, the marchers made two stops, the first when shouts commanded, "Spread out." About two hundred

A marshy spot along the prairie, such as the one that impeded marchers seventy-six years earlier on their way to the Republic plant. *Photo by John F. Hogan.*

left the path and moved west, onto the field and toward the plant fence. Just when the police thought the marchers were trying to outflank them, the smaller group found the footing too spongy and headed back to the main column, which stopped a second time to allow them to catch up.

Controversy developed later over whether or not the advance represented that of a military-style formation or a disorganized mob. Some of the police and their defenders, alleging precision, cited the commands to fall in, the organization of orderly columns and the positioning of men according to their place of employment, with everyone following two flags lofted in the breeze. Captain Mooney asserted that in the days preceding the event, strikers were drilling "a hundred at a time and forty at a time." Mooney no doubt was alluding to an alleged "confession" by a never-identified strike captain who supposedly said strikers underwent two days of military-style preparations. Five policemen who confirmed the man's story said they observed the drills separately and at different times Friday and Saturday in the prairie near Sam's Place. The credibility of the information came into serious question when Mooney let the allegations drop after this single, cryptic mention. Non-police witnesses described marchers "mixing into

line without any order whatsoever," looking like "a group of picnickers" enjoying a "holiday atmosphere." Newspaper photos and the Paramount newsreel footage, which would become critical evidence, confirmed the lack of organization. Even the police couldn't agree among themselves. In his report to the commissioner the day afterward, Captain Kilroy described the marchers as "a very disorganized mob."

Perhaps both characterizations were correct. The shape that the gathering took outside Sam's Place probably looked a lot different from the one that arrived at the middle of the prairie. For one thing, two hundred or so participants had veered off and then rejoined the ranks. Witnesses at opposite ends of the march—Kilroy to the south, and the reporters to the north, among others—described what they saw from their particular vantage points, blocks apart from one another. The newsreel didn't capture the start of the parade. Following the confrontation with the police, a march that had begun with at least a semblance of order and lapsed into apparent disorganization would end in a rout.

The approximately forty pickets allowed by the police in the immediate vicinity of the plant provided an ironic counterpoint to what was about to take place on the prairie—a friendly relationship with the officers standing guard at the facility. Wearing signs that read "We Are on Strike" and "Don't Be a Scab," the pickets frequently would wave at their supposed adversaries. "I knew some of the pickets personally and they called me by name," mentioned Lieutenant John Ryan, who commanded one of the platoons that would clash with the advancing strikers. Other platoon leaders agreed: the pickets confined themselves to the area in front of the plant and never caused any trouble.

Inside the gate, tension was building as police milled around, waiting for the command to move out. Captain Mooney had briefed Ryan and the other platoon leaders on the information he'd received that the marchers intended to storm the plant and evict the "loyal" workers. Mooney emphatically told his lieutenants that no one was going to get past them. Each platoon leader inspected the revolvers and batons carried by his men and swore later that none possessed any non-regulation weapons. In almost identical affidavits, each further swore, "At no time did I give any order to police officers under my command to fire a revolver." The disclaimer was somewhat disingenuous in that no commander stood accused of issuing an order to shoot.

A little before 4:00 p.m., Mooney moved one platoon to the railroad gate at the north end of the plant and ordered four others to proceed out of the main gate and north on Burley Avenue. The larger force assembled near

117th, where Burley ended and joined the dirt path. The last house on the street belonged to a Republic striker named Robert Fleming, who watched the police gather from an open second-floor window. He could hear them talking loudly, twenty to thirty feet away. Fleming, his young daughter and a teenage neighbor boy enjoyed a clear view of the field, all the way back to Sam's Place. The steelworker didn't explain why he was at home, listening to a ballgame on the radio, instead of marching or holed up inside the plant. The Fleming front porch soon became a popular spot for watching the unfolding drama. Everett C. Parker, a newsman from a radio station in Hammond, Indiana, could see the marchers approach, first from the top of a shed and then from Fleming's porch. Parker described the policemen lounging around in informal groups until the order came to fall in. Then the officers donned their heavy blue coats, despite the heat, batons clutched firmly in hand. In the distance they could see the marchers kicking up a little dust, hear them singing a union song and chanting, "C-I-O, C-I-O." The police waited nervously, not sure which direction the march would take. At the plant, workers peered out through cracks or from rooftops. Some yelled, "Here they come!"

CHAPTER 8
DEATH ON THE PRAIRIE

L ieutenant Bart Moran thought it would be useful to have tear gas on hand if the oncoming crowd refused to disperse. Captain Mooney liked the idea, so two patrolmen were dispatched in a squad car to retrieve some gas from the temporary police headquarters inside the Republic gate. Captain Kilroy apparently was unaware that tear gas was available. The steel company, which owned the stuff, could easily spare a carton of projectiles since it had been stockpiling for years and had just laid in a fresh supply less than three weeks earlier.

About this time, the police parked two wagons side-by-side, just below Green Bay to block the road, probably assuming that the marchers would follow the same course as Friday night. When Mooney saw them turn onto the dirt path, he realized that his men were out of position to confront them. "When it was determined [which way] they were coming," Moran explained, "Lieutenant Ryan's platoon advanced into the prairie…and my platoon was ordered to follow Ryan's." Quickly, four platoons lined up across the path, just north of Robert Fleming's house, while a reserve column double-timed out of the plant to reinforce the line. About two hundred officers, standing in double rank with batons drawn, spread out about 160 feet across the path. Mooney stationed himself on the east side of the line, close to where Moran was standing near one of the wagons that had just been moved up. It was here that the tear gas was delivered. It was also here that the officers who had clashed with the strikers Friday night were positioned. Kilroy got the assignment to move front and

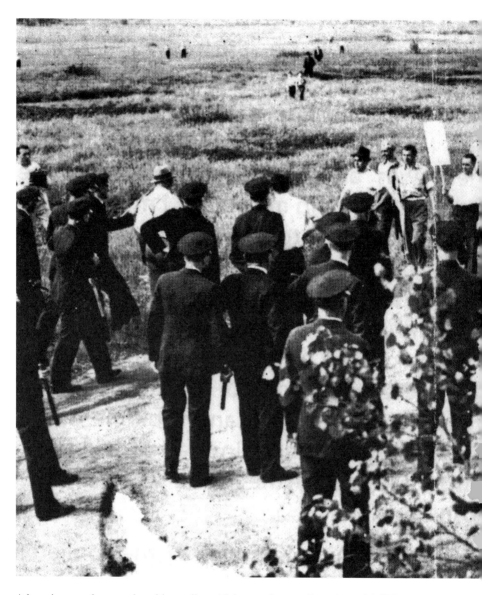

Advancing marchers reach waiting police with batons drawn. An estimated 1,500
demonstrators confronted some 260 officers. *Courtesy of Local 1033, SOAR.*

center and, when the noisy, shouting marchers arrived, command them
to disperse peacefully.

To anyone familiar with Chicago history, the order was foreboding.
Mooney spoke the words first and only once. Kilroy, forty yards or so to

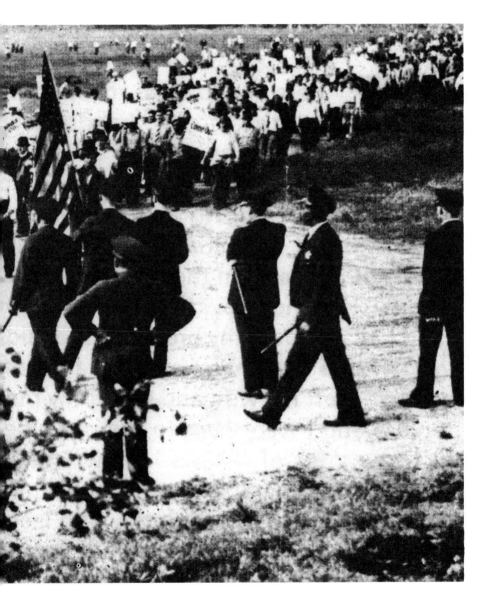

his west, would repeat them several times: "In the name of the people of the state of Illinois, I demand you disperse peacefully and quietly." The directive was almost an exact quote of the one delivered by a police commander on another day in May, fifty-one years earlier, in the city's Haymarket Square, immediately before someone hurled a powerful dynamite bomb into the ranks of officers trying to disperse another gathering of angry, frustrated labor protesters. When the smoke cleared,

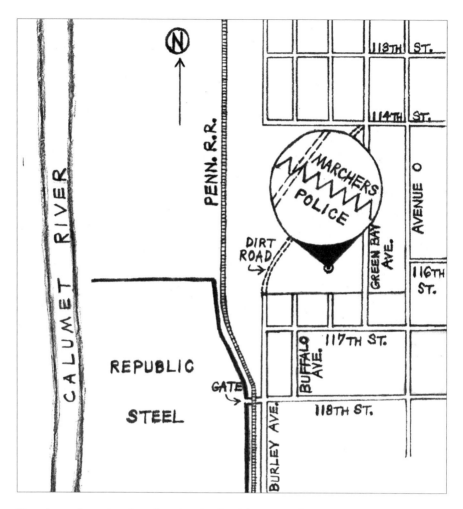

How the confrontation shaped up shortly after 4:00 p.m. on Sunday, May 30, 1937. *Courtesy of Alex A. Burkholder.*

seven policemen had been killed and forty other persons, civilians as well as police, had been wounded.

Mooney said the only reply he got was from an unidentified man about thirty-five years old "holding a big club with a meat hook on it," who told the captain, "I will put that through your skull." Bauman, the *Herald and Examiner* reporter who was standing nearby, confirmed the encounter. Others who came forward insisted that they weren't looking for trouble. Anton Goldasic had a smile on his face when he put his hand on Mooney's shoulder and said, "I can't understand why you fellows don't leave us march through and establish a picket line.

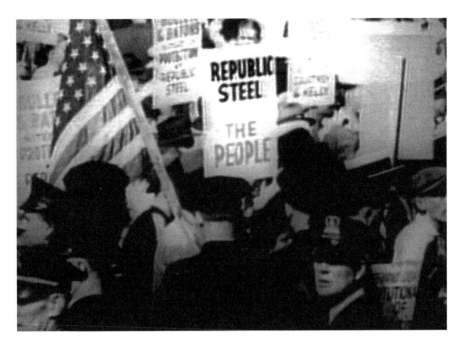

The confrontation begins. Marchers demand to be allowed through police lines so they can picket the Republic plant. *Courtesy of the Illinois Labor History Society.*

"And he says, 'I can't let you fellows through. You men have got rocks and bricks and whatnot.'

"And I says, 'Well, I don't see any. But, I says, if there is any, I will see that they drop them if your men will spread out and let us march through.'

"And he says, 'No. I can't let you do that.' He says, 'I have to follow orders.'

"And I says, 'Well...naturally...you have to follow orders. If you don't, it's your job.'"

By all accounts, this was one of the few cordial exchanges between the police and marchers who stood facing one another about a yard apart under the hot sun. Profanity, some of it particularly vile, came from both sides. Soon after the first marchers reached the police line, some strikers fanned out as others farther back continued to push forward, seemingly in an effort to hear what was being said. The front rank now stretched as far across the field as the police line. Those who headed for the opposite flanks were armed with clubs and rocks. Many of the policemen waiting for them on the eastern flank remembered Friday night.

George Patterson also tried a diplomatic approach with Mooney, asking him to allow picketing and "escort us peacefully, to aid us [in setting] up our picket

lines." The captain was finished with diplomacy. "He looked through me, down at me. Like he neither saw nor heard me. He took the paper he had in his hands and brought it smartly down. Turned away from me while I kept pleading with him." Down the line, Kilroy was neither conversing nor listening. He kept repeating over and over the command to disperse peacefully.

Other marchers in the front rank didn't have any better luck imploring police subordinates. When he stopped at the police line, flag-bearer Guzman said a plainclothes officer told him, "Lucky you are carrying that flag or you would have been shot." The other flag-carrier, John Lotito, did get shot shortly afterward—in the lower leg—after being clubbed, falling down with his flag, getting up, absorbing another clubbing and then "half running, half crawling" in an effort to get away.

Police ordering the crowd to disperse, members of the crowd demanding the right to picket. The unbending positions were repeated for at least three and possibly as long as ten minutes. The marchers were growing increasingly excited. Everyone was hot, but an observation by Officer Philip Igoe that some of the marchers appeared high on marijuana was never taken seriously by objective observers.

During nearly all of the face-to-face standoff, a Paramount newsreel camera, operated by Orlando Lippert of Chicago, continued to roll. Mounted on a truck behind police lines, the camera panned the confrontation, occasionally zooming in for a close-up. "It is apparent [from the film, which runs just under eight minutes]," the La Follette report noted, "that the marchers were engaged in earnest and heated debate with the police. Fingers point to placards on which slogans demanding the right to picket are enscribed. Arms are flung in the direction of the plant gate, indicating the point at which the establishment of a picket line is demanded."

The exact sequence that unfolded over the ensuing seconds has never been pinpointed with complete certitude. The split-second turn of events was so telescoped that police, strikers and witnesses—impartial or otherwise—have offered differing perspectives, influenced by their vantage points, partisanship, if any, and perceptions easily shaded by sensory overload. At a critical moment, the camera was unable to help. For about seven seconds, all the time it took for heated confrontation to devolve into mayhem, Lippert was changing lenses. He testified that during this break, marchers back in the crowd pushed forward, shoving those up front into the police, who must have assumed they were being attacked.

After the arguments had gone on for several minutes, some of the marchers apparently realized that the police were not going to give in. The

last striker to speak with Mooney turned partway toward those behind him as if to convey that conclusion, according to Ralph Beck, a "stringer," or part-time reporter, for the *Chicago Daily News*, whose testimony would strongly influence the La Follette subcommittee. At this moment, someone about twenty feet back in the crowd hurled a tree branch toward the police line. One account had the branch striking an officer. Before the branch had reached the peak of its arc, Beck heard a single gunshot and turned to see a policeman, believed to be Officer Igoe, holding a revolver in the air. Beck said the officer fired twice more. Other witnesses, including newsmen, told of seeing gun smoke or hearing one or two shots that seemed to come "from somewhere back in the crowd," in the words of John Pulsis, an Associated Press photographer. Pulsis photographed the action from Fleming's front porch, where observers continued to gather. Captain Kilroy, too, claimed that the first shot came from the ranks of the strikers, although he later weakened in his opinion under stiff cross-examination by Senator La Follette. Nevertheless, reports by responsible persons that the first shot or shots came from the strikers gained immediate credibility. In the following morning's editions, the *Tribune* reported, "When the rioters resorted to firearms, the police said, they were forced to draw their revolvers to protect themselves." The controversy offered a precursor of events in Dallas twenty-six years later when some eyewitnesses to the Kennedy assassination swore they saw what appeared to be gunfire coming from a grassy knoll along the presidential motorcade route.

One of John Pulsis's photos captured the thrown tree branch in mid-air. The picture also "shows several policemen…apparently in the act of dodging or holding up their hands to protect their heads," the cameraman stated. "This picture also shows the smoke trail of a tear gas bomb in the act of being thrown toward the crowd."

Captain Mooney ordered the use of tear gas after a shower of rocks, stones and other missiles were hurled at the police, and immediately after the third police shot was fired in the air. "We were continually ducking…a great volley of stones," Lieutenant Moran related. "All the policemen were ducking." *Tribune* reporter Kennedy's estimate, that "possibly a couple of hundred" missiles were thrown, may have been an exaggeration. Newsman Bauman described the airborne debris as looking like "a flock of birds."

Mooney told Moran to have an officer throw some tear gas bombs into the ranks of the strikers. The lieutenant, in turn, had Officer Kirby take the bombs to the east side of the police lines so they would catch the desired wind direction. It immediately became obvious that Kirby didn't know what

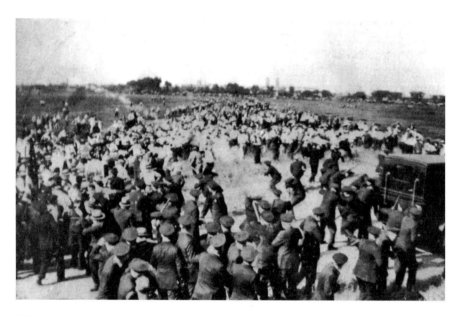

Police on the right dodge missiles thrown from the crowd while a plume of tear gas is visible in the upper left. *Courtesy of Local 1033, SOAR.*

he was doing. He fumbled with the first bomb but finally got two of them off that sent the marchers on the eastern flank retreating back across the field. "Shortly after the bombs were thrown," Moran stated, "a free-for-all fight broke out but lasted only a few seconds." The Guard observer said strikers responded to police clubbing with clubs and stones of their own.

Reporter Beck, who was standing next to Captain Kilroy at the center of the police line, told of seeing "a large number of policemen immediately around me and to my rear [draw] their guns and [fire]—those in the rear firing into the air, and I saw a few on the front line fire point-blank into the crowd." Like the proverbial birds on a wire, a volley of two hundred shots, in Beck's estimation, followed the few shots fired into the air by a single policeman. Kennedy, the *Tribune* reporter, as well as the Guard officer, also estimated the number of shots at two hundred. The military observer, Captain Cartwright, said he spotted many police in the second rank firing overhead while a few in the front were firing low, into the legs of the crowd. Cartwright never reported seeing guns in the hands of any marchers. He did see a boy, later identified as eleven-year-old Nicholas Levrich of the East Side, get shot in the left foot and picked up by two demonstrators fleeing the police onslaught. Nicholas asked the guardsman to notify his father. The youngster spent ten days in Burnside Hospital with

a compound fracture of the left heel. Another boy and a girl also were said to be shot, but none of the receiving hospitals recorded any children besides Nicholas among the wounded.

Carl Harris, a reporter whose affiliation wasn't given, added that the police were firing from a position where they were in no danger of their own lives. "They were completely safe and at least fifteen to twenty feet away from anyone." George Patterson said, "A black policeman was down on one knee, taking careful aim and shooting at us. The smell of gas and gunpowder was strong in the air. An awful anger seized me."

The firing lasted only ten to fifteen seconds, but the toll was devastating—four killed immediately, six fatally wounded and thirty more injured by the shots. "The police," Beck continued, "put their revolvers back in their holsters, those who had them out, and started to work with their clubs. Those who had not trained their guns set to work immediately with their clubs."

What followed was a "police riot," to use the term employed by the presidential commission that investigated the 1968 Democratic convention disorders in Chicago. After the tear gas was thrown into the crowd standing to the east, those marchers turned and fled. Instead of watching them

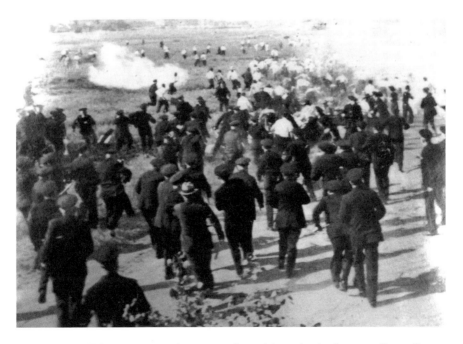

The rout is on. Police pursue marchers across the prairie as clouds of tear gas linger. *Courtesy of the Illinois Labor History Society.*

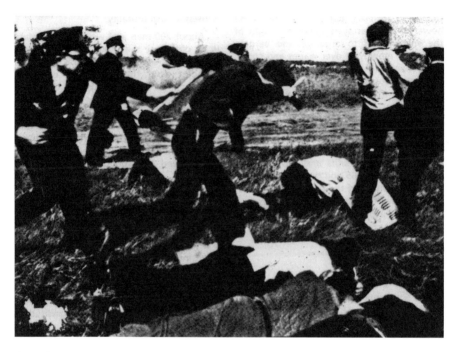

One of those still standing takes a blow to the back from a light-colored club apparently drawn from the Republic plant arsenal. Regulation police batons were dark. *Courtesy of Local 1033, SOAR.*

go—mission accomplished—the police took off in hot pursuit, swinging their batons. When the marchers positioned toward the center and west saw this happening, they, too, tried to escape but found their way partially blocked by a mass of tangled bodies of gunshot victims or those who had fallen in their haste to get away.

Reverend Chester Fisk, who was carrying a movie camera, believed he got film of a policeman shooting at retreating strikers from long range. He also made close-ups of a young man who had just fallen facedown with bloodstains on the back of his shirt from an apparent gunshot wound. Already having witnessed policemen chasing strikers across the field, clubbing them from behind, Reverend Fisk saw something that particularly appalled him. "Not more than forty yards away, I saw two policemen chasing one young fellow, who was running as fast as he could, and shouting over his shoulder, 'I'm going, I'm going. I'm doing what you told me to do. I'm going as fast as I can.'" Fisk said the man tried to jump across a ditch but stumbled, "and these two policemen coming up on him simultaneously struck him down behind a little clump of bushes and then stood there for a couple of minutes slugging him. I

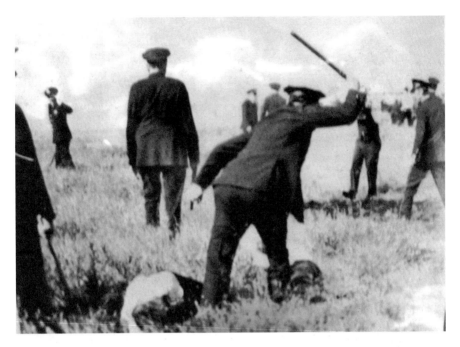

A policeman prepares to club a prone marcher as another officer, possibly Captain Thomas Kilroy, stands with his back to the camera, seemingly oblivious to the beating. *Courtesy of Local 1033, SOAR.*

have pictures of them standing over him, hitting him with their clubs five or six times after he was down and apparently unconscious."

Reverend Fisk should have said he *had* pictures of the beating. Police confiscated his camera when they arrested him for no apparent reason other than being on the field. They returned the camera the following day, minus the film. Reverend Sanford also had a camera with him that day, but the investigating subcommittee didn't find either set of film helpful.

Captain Cartwright witnessed the same scenes as Reverend Fisk. "At this point, the paraders were running, falling through the swamp on either side of the road, some choking from tear gas, others bleeding from head wounds." Women were screaming, men shouting. Police surrounded demonstrators who had fallen and clubbed them when they tried to get up. Some who managed to get away regrouped at a distance and threw stones at the police, an act of supreme defiance or stupidity, considering that about two hundred rounds had just come from the ranks of their targets.

In addition to those shot, sixty more strikers or supporters suffered non-gun-related injuries. Thirty-four police officers were hurt. Their most serious

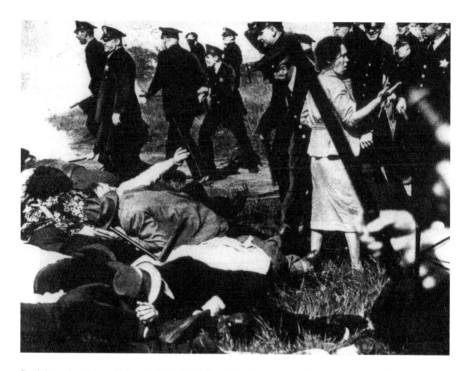

Social worker Lupe Gallardo Marshall, four-feet-eleven and ninety-seven pounds, stands between advancing police and fallen marchers. *Courtesy of Local 1033, SOAR.*

injuries were a few broken arms, sprains and kicks. Of the nine persons who were in the front line of the march at the time of the outbreak, seven were clubbed, one was shot and only one escaped without injury. Nearly all the civilians injured were in their twenties or thirties.

Louis Calvano, a nineteen-year-old employee of Wilson Steel Co., was stationed between the two flag-bearers when a policeman asked him why he was marching. "Then he yelled, 'Duck!'" said Calvano. "As I ducked, he hit me on the head." The young steelworker turned and began to run when a black man whom he learned was Lee Tisdale took hold of him and helped him get away. Already dizzy from the tear gas, Calvano had gone just a short distance when he said a bullet grazed his right cheek. "Just before this, Lee Tisdale had left me. I do not know if he was clubbed then or not." Tisdale, in fact, had been shot. The fifty-year-old Youngstown laborer died three weeks later of blood poisoning from an infected bullet wound of the right thigh, the last of the ten fatalities and the only African American to die.

Jim Stewart, holding his "Bullets and Batons" placard near the flag-bearers, related a similar experience. As Captain Kilroy continued to read

his statement, Stewart engaged in a non-threatening conversation with two patrolmen. The union leader and one of the officers agreed that neither wanted any trouble, but as soon as Kilroy stopped reading, the other policeman swung his baton and hit the sign. The first officer also swung, hitting Stewart on the forearm as he tried to shield his head. Then he heard the shots.

"The policeman immediately in front of me…started drawing his gun…[but] he was having quite a struggle to get it out. It was a brand new holster." Stewart ran, collecting several blows to the back along the way. "After I got a little bit clear of the crowd, a man alongside me dropped. I thought he had just stumbled, as I had done myself several times. But as I passed him up, he shouted, 'I'm shot.'" Stewart and two other men on the run picked up the victim and carried him until one of the union cars arrived to take him back to Sam's Place.

Another in the front rank, twenty-nine-year-old Swedish immigrant Hilding Anderson, died of a gunshot wound to the right side of the abdomen. Patterson wasn't with the Carnegie Steel rigger when he got hit but remembered him "always laughing, so carefree, so full of life. I am sure he met the police with a joke. With his pleasant Swedish accent, I could hear him say something funny, like, 'Yumping Yimmie, let [us] through and picket.'" Patterson's brother donated blood, but Anderson died in Bridewell Hospital five days after getting shot.

First aid cars were picking up the wounded and dying when the first of five police wagons moved onto the field. What amounted to a grim contest ensued to see whether the police or the strikers would be first to reach the victims. Demonstrators who were able made it back to Sam's Place, leaving many of their companions stretched out on the field. If the police reached them first, the prostrated got dragged off to the wagons, shoved in till the vehicles were full and taken on leisurely rides to hospitals that weren't necessarily the closest ones. The more fortunate received far gentler consideration from their colleagues who removed them to Dr. Jacques's field hospital for immediate treatment followed in many cases by a transfer to a conventional medical facility.

Soon after the first police wagon arrived, the Guard captain said, "A group of men still choking from the tear gas [and] some who were injured dashed across the field and said, 'Let's get that paddy wagon.'" The policemen escaped "by a narrow margin," Cartwright reported, especially those on the rear step who avoided getting hit by stones and thrown clubs. The observer said he heard a number of threats from the retreating marchers:

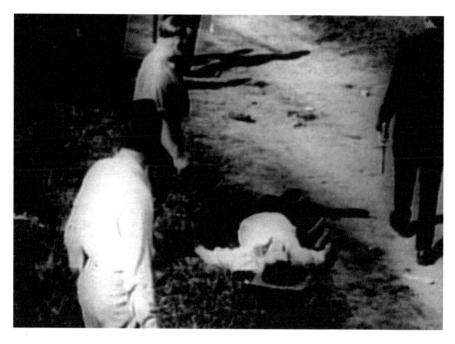

Fellow marchers attempt to aid a fallen man. Some of the wounded were picked up by union medical cars and taken to a makeshift field hospital at Sam's Place. *Courtesy of the Illinois Labor History Society.*

"I wish I knew where one of these policemen lived. I'd find his wife and kill her."

"The only way to get the dirty scabs out of that plant is to burn down the homes of a couple of them so that their families will be out in the street; then they will come out."

"Look at the policemen standing on top of the building in the Republic plant; I bet they have machine guns there." The men on the roof were company employees watching the battle.

Some of the police related their own gripping stories. None topped those of Patrolman George Higgins, who seemed to be everywhere. First, he told of coming upon a fellow officer who had been felled either by a bullet or thrown object. Having lost his baton, Higgins said he approached a striker standing nearby who was holding a slingshot fashioned from a crutch. After punching the man to the ground, and with "missiles…still flying…our boys falling here and there," he heard someone holler and saw an officer later identified as Sergeant Walter Oakes "flat on his back [with] a fellow bigger than he bending over him, trying to bend his knee under his throat." As

Higgins went to help Oakes, he said he was approached by yet another striker carrying a club, but before the man could swing, Higgins "just cracked him down. I got in on him before he came down with the blow."

Things were only beginning to get interesting. Higgins said he heard a shot and saw the man attacking Oakes draw back, "a nickel-plated revolver in his hand." The man clutched his stomach, according to Higgins, and Oakes fired three or four more times as he tried to get up off the ground. The man went down. He was identified as Joseph Rothmund, age forty, a German-born baker who had been living on West Belmont Avenue in Chicago. Rothmund was employed by the federal government's Works Progress Administration (WPA) and was identified by his wife as a Communist Party member. Higgins alluded to Rothmund's political affiliation during a subsequent interview with two members of the Senate subcommittee staff: "Oakes shot him again and perforated him in the stomach. This was the lousy Communist." Rothmund may have been a Communist, but he most certainly wasn't shot in the stomach. "The unimpeachable evidence of the coroner's autopsy discloses that Rothmund…was killed by a single shot which had its point of entrance at the almost mathematical center of the back," the subcommittee report asserted. Labor historian Adelman was more blunt: "Photos and films proved that Oakes had attacked Rothman [*sic*] and then shot him in the back as he fled." A search by police failed to turn up either a nickel-plated revolver or a slingshot made from a crutch.

Not until nearly three weeks later, stung by attacks that said the police had fired indiscriminately, did the police department mount a media counterattack. Police brass made available to the *Tribune* ten officers who admitted firing their weapons. Collectively, they said they fired a total of eighteen shots, either in self-defense or to protect fellow policemen. Eight told of seeing strikers firing guns. Of the rounds fired by police, fourteen were said to have gone into the air, one into the ground, two at the legs of an attacker and one that dropped an assailant. Patrolman Lloyd Casey described getting knocked to the ground by a brick and then being approached by "a big fellow" carrying a pole with a meat hook on the end of it. "I warned him to stay back," said Casey, "and fired one shot into the ground. He called me names and kept coming towards me. Then I fired at him and he dropped, about fifteen feet away."

It was impossible to tell how many shots all together were fired by the police by comparing before and after bullet totals because each officer was responsible for supplying his own ammunition. No inspections or tests were performed to determine which revolvers had been fired.

Meanwhile, Patrolman Higgins wasn't finished after the Oakes-Rothmund confrontation. He encountered Lupe Marshall, the four-foot-eleven, ninety-seven-pound mother of three. Higgins said the thirty-one-year-old social worker "was hollering and yelling, and I saw something in her arm and she seemed to want to get it open. I did not strike the lady," he insisted. "As a gentleman," he merely shoved her and she fell to the grass holding a package, which Higgins described as a half-pound or pound bag of soft pepper. He said he and other officers impounded the contents. Marshall denied carrying pepper, and close-up photos of her taken about this time showed her wearing a matching skirt and jacket, medium-heel shoes and holding a purse and several newspapers but no bag of any kind. The police inventory of confiscated items didn't list a bag of pepper.

Next, Higgins described moving near Captain Mooney and spotting a tall man wearing a blue shirt carrying a sawed-off shotgun. The man fired once, Higgins claimed, before ducking back into the crowd. No buckshot wounds were found among any of the injured.

The language of the subcommittee report couldn't have been more direct: "In the light of these facts, we can characterize Patrolman Higgins' testimony only as the product of a highly-inflamed imagination or an act of deliberate perjury."

For sheer outrageousness, nothing Higgins said topped his claim that he applied a tourniquet to the thigh of Earl Handley, a thirty-seven-year-old Inland Steel carpenter. An artery in Handley's right leg had been pierced by a bullet. Handley was being carried in a blanket by two civilians, his leg saturated with blood from hip to ankle. Higgins was nowhere in sight, unless he was among a group of officers who variously laughed, swore or interfered with Handley's predicament. Archie Paterson (not to be confused with George Patterson) and John Jablonski were picking up other wounded in a union car when someone directed them to Handley. They had to cut through a police line with Paterson driving and Jablonski on the running board to reach the injured man.

"At a glance, I saw the man was in a bad way," Paterson related. "From the appearance of his face, he was losing blood rapidly." Paterson tried to make a tourniquet, using a strap he found laying across Handley's knees, but had trouble adjusting it. He asked some of the police for help, but "they only laughed at us and swore at us." With the help of the men who had been carrying Handley, Paterson and Jablonski got the victim into the car. As they were about to leave, an officer standing about ten feet to Paterson's left drew his revolver and ordered them to stop. Another policeman to the

right said, "We will get one of those sons of bitches anyway," according to both would-be rescuers. "Get him out of there." Paterson pleaded with the officers. Medical help was only a two-minute drive away, at Sam's Place, he explained. Five or six policemen were now standing around the car. As Jablonski reluctantly started to comply with the order, he said one officer "took him right out of my hands and then dragged him along the ground to the patrol wagon." Paterson, Scottish by birth, like Patterson and Stewart, said, "Four constables got hold of the man, one by each arm, and one by the left knee and one by the tourniquet I had put on his right thigh. As he [the policeman] grabbed the tourniquet, it slipped to the knee…and the blood was pouring…out of the top of his trousers." Paterson said he saw Handley at South Chicago Hospital about fifty minutes later when a police wagon arrived with him. "He was dead, had not been attended to, and the tourniquet was still around his knee."

Whether or not the proper application of a tourniquet could have saved Earl Handley's life became the sharpest of many points of disagreement between Dr. Jacques and Dr. Jerry Kearns, a coroner's pathologist. Dr. Jacques maintained that the procedure "could certainly have saved his life" and that carrying the wounded man without a tourniquet "may have contributed to his death." Dr. Kearns was just as insistent that the procedure would have made no difference; Handley would have died anyway.

The two doctors quibbled over the wording of postmortems and the entrance points of fatal shots with Kearns apparently trying to give the police what little benefit of the doubt they may have been due. For instance, Kearns's postmortem of Sam Popovich, a fifty-year-old Inland Steel laborer, mentioned that he died of a "bullet wound of the head," which was true. Jacques emphasized that Popovich was shot squarely in the back of the head. Anthony Tagliori, twenty-six years old and the only Republic employee killed, died of a "bullet wound of the abdomen," according to Kearns's postmortem. Jacques described the bullet entering Tagliori's left buttock and then perforating the bowel and bladder. The six men whom Kearns listed as shot in the abdomen were shot in the back, in Jacques's opinion. In a few cases, the doctors drew a fine line between back and side. Not in dispute was the fact that none of the ten took a fatal bullet while facing forward. All the dead, the overwhelming evidence revealed, were either fleeing the police or turning to run away.

With regard to the remaining findings:

Alfred Causley, a forty-three-year-old steel mill carpenter, was the only demonstrator shot multiple times, in Kearns's analysis, taking four bullets to

the chest and abdomen. Jacques referred only to an entrance wound to the left side of the abdomen.

Telegraph messenger Leo Francisco, at seventeen the youngest victim, died of a through-and-through bullet wound of the abdomen, according to Kearns. Jacques said the bullet struck the back of the thigh.

The doctors agreed that Otis Jones, a thirty-three-year-old ironworker employed by Fruit Growers Express, died of a bullet wound to the spinal cord.

Finally, Kenneth Reed, a twenty-three-year-old lineman employed by an unnamed steel company, suffered a bullet wound of the abdomen, in Kearns's judgment. Jacques said Reed incurred superficial wounds to the arm and chest but was killed by a bullet that entered the left side of the back.

In the non-fatal gunshot cases, a similar pattern appeared. Only four of thirty persons were hit from the front.

Dr. Jacques treated a number of patients at Sam's Place immediately after they'd been injured. These were the ones lucky enough to get there under their own power, with the help of fellow marchers or in one of the "Red Cross" cars. When the doctor first heard explosions and saw smoke out on the field, he assumed that he'd be treating tear gas cases, "not possibly... gunshot wounds."

"Within a few minutes...the injured began to be brought in. Within four or five minutes, there were approximately thirty or forty bleeding, groaning, screaming, dying, and, I thought, one dead person." Jacques felt overwhelmed by the number of gunshot cases and "gave instructions that all gunshots, without exception, were to be removed immediately to the hospital, beginning with those who looked sickest."

South Chicago Hospital, where many of the injured were taken, also became overwhelmed and called Jacques to help in its emergency room. When he arrived, he found the ER "crowded tightly with carts on which injured people were lying, with interns and nurses squirming between carts trying to help them." He noticed a large number of policemen and "two men who seemed to be desperately wounded" (Anderson and Tagliori). Jacques said the police were intent on taking some of the injured to jail and called him away from his work several times to press their demand. "I told them that, in my opinion, it would be neither safe nor humane to move any of them, and I refused permission."

How some of the wounded got to hospitals, if they got there at all, presents a story in itself. The La Follette report concluded that police "treatment of the injured was characterized by the most callous indifference to human life and suffering. Wounded prisoners of war might have expected and received

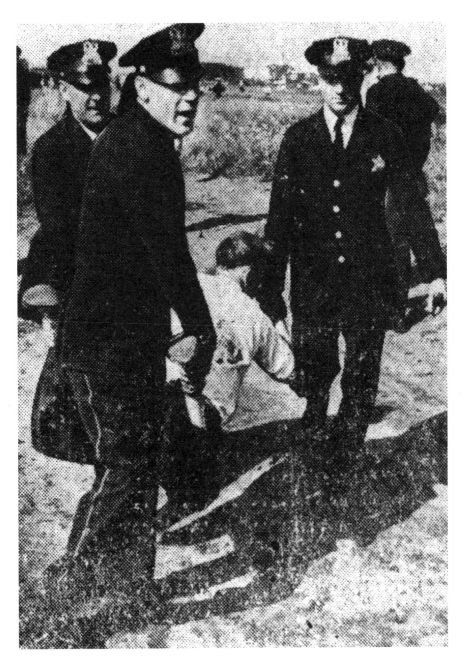

Police carry one of the wounded, possibly Earl Handley, off the field to a waiting patrol wagon. There were no ambulances because police said they didn't expect so much violence. *Courtesy of the Illinois Labor History Society.*

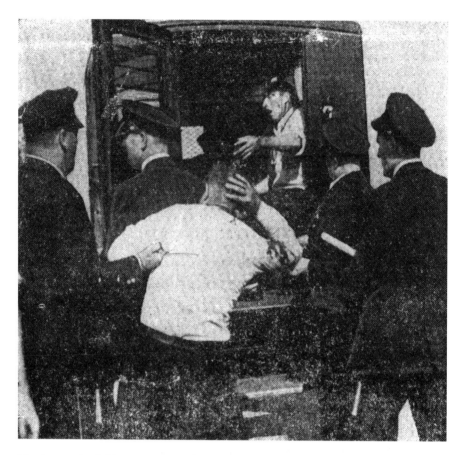

Marchers are loaded into a police wagon for the ride to hospitals or lockups. Some said the police deliberately delayed trips for medical aid. *Courtesy of the Illinois Labor History Society.*

greater solicitude." Police not only made no attempt to provide first aid, but they also shoved wounded and dying marchers along with the uninjured into patrol wagons until they were filled with bodies piled on or jammed against other bodies. Then, instead of rushing to the nearest hospitals, some drivers took slow, circuitous routes, often bypassing the closest facility. Police officials explained later that no ambulances or additional wagons were available because they weren't anticipating this level of violence.

Paul Tucker, the West Side chemist who rode more than twenty miles to the demonstration, may have survived because he got picked up by a union medical car that didn't get stopped by the police. "I felt something crack me in the back," Tucker recalled, "[but] I didn't think I was shot. I was sure it was only tear gas." Tucker said he felt great pain but feared that if he stopped

in place he'd get killed or, at a minimum, beaten like those he saw lying on the ground. He ran as best he could until his rescue and was transported to South Chicago Hospital. Because of overcrowding, Tucker was turned away from there and wound up at Burnside Hospital, several miles west, where he was diagnosed with a gunshot wound through the pelvis, bowel and bladder.

SWOC organizer Harry Harper also got picked up by a union car but endured an experience similar to that of Earl Handley. In other words, he got legally kidnapped but lived to tell about it. Another of the front line marchers, Harper told of talking with an officer standing near Captain Mooney when he was clubbed repeatedly on the left side of the head. "The blood was gushing out of my face. It was running in my mouth…I was in a crouching position so the blood would not strangulate me." Harper lost his left eye in the beating and temporarily lost the sight of his right eye after it was burned by an exploding tear gas bomb. (Curiously, Harper claimed in an undated reminiscence, reprinted in 2007, that he lost the eye to a gunshot. "Immediately a gun came up to my head and then the bullet tore through, tore the eye out and I was blind.")

Some of the retreating marchers picked him up and placed him in a medical car that started out for the hospital. Before the vehicle could get very far, it was stopped by police, who removed Harper and put him in a patrol wagon with two men stretched out on the floor and another propped on a seat. The seated man, who apparently had been shot in the leg, "was begging the officers to take us to the nearest doctor or hospital but the officers refused." Harper, too, said he begged for first aid because he was in agony. "Shut up, you son of a bitch," he said he was told. He thought the wagon may have stopped briefly at South Chicago Hospital before continuing to Bridewell Hospital, the jail infirmary, more than fifteen miles away. Harper said the trip took "ages"—three hours, he was told later. "I could not see; my left eye was cut and my right eye was closed entirely, and my face was a mass of blood." He mentioned that one policeman said to the other, "We will take this one [Harper] in. We will take the others to the morgue—no use bothering with them."

Harper spent several days at Bridewell Hospital, largely ignored by doctors, he claimed, before he got "sprung on a writ" and moved to Michael Reese Hospital (private) for "real medical attention." A doctor told him he couldn't perform the optimal operation "because the infection was a half-inch from the brain already because of lack of attention, but he was able to take out the slush and saved my life by doing that."

The first wagon that police tried to load Reverend Fisk into was so full of wounded prisoners that there was no space for the minister, appropriate

because he was uninjured and had done nothing except observe and shoot film of the beatings. "We might as well run him in, too," Fisk quoted one policeman as saying. A second wagon was not quite as full, so Fisk was made to join eleven others, all but one or two injured and four "desperately wounded," according to the clergyman. "Two of them had their heads laid open in several places so you could barely see their hair for the blood…and their shirts were so soaked in blood that you could have wrung them out. Two other men were beaten so nearly into unconsciousness that they were sitting on the seats of the patrol wagon in a daze, rocking back and forth, almost falling out of their seats."

Reverend Fisk was held overnight at the South Chicago District police station and released at noon the following day.

Lupe Marshall, meanwhile, found herself in a wagon with sixteen seriously wounded men, "piled one on top of the other." Marshall was tossed into the vehicle after her encounter with Officer Higgins during which the ubiquitous policeman shoved her to the ground and called her an obscene name. Between that experience and her arrival at the wagon, she was clubbed a few times by other officers. Inside the vehicle, she began to minister to the injured, some with their heads underneath other bodies, some with twisted arms and legs.

"I started straightening out their heads and lifting their arms from underneath." She noticed one man "who looked very gaunt and haggard." Marshall placed his head on her lap and "noticed that his face was cold and turning black." The man motioned that he wanted a cigarette, but when Marshall took one from the pack in his shirt pocket, she saw that it was soaked with blood. "Never mind, kid," she quoted him as saying, "you are all right. You are a good kid. Never mind. Carry on." Marshall said the man started to say, "Mother…" but didn't finish the thought. "He stiffened up and I became hysterical…It seemed we drove all over the city of Chicago before we got to the hospital…and every time the patrol wagon jolted, these men would go up about a foot or so, and fall on top of each other, and there was the most terrible screaming, groaning…going on in that wagon."

One of the women who belonged to the group behind Marshall during the confrontation had a good cop/bad cop experience. Twenty-two-year-old Ada Leder, wife of a Republic striker and five months pregnant, was with her companions in the center of the field singing "Solidarity Forever" when the trouble started. She admitted that she had "a little stone" but didn't use it. A member of the CIO Women's Auxiliary, Leder got whacked across the backside by a policeman's club but "did not want to lie on the ground because

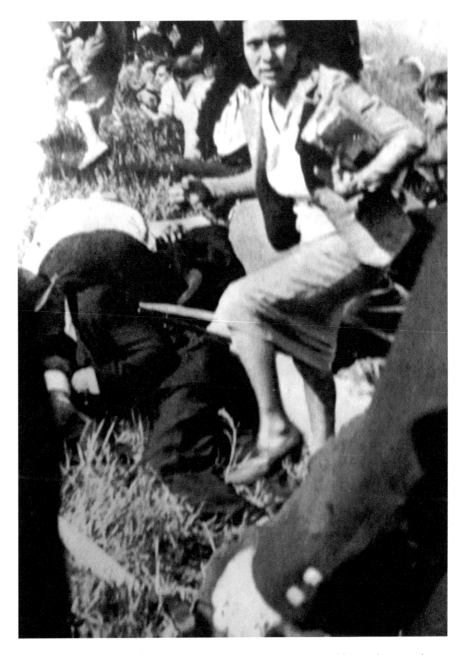

Lupe Marshall, shortly before her arrest. Marshall said police shoved her to the ground, clubbed her and called her an obscene name. *Courtesy of Local 1033, SOAR.*

I was afraid I might get trampled on." Another officer who "was very nice" stepped in and said, "Don't hit her." She said the second policeman took her aside and said, "You stay with me." He escorted Leder to a wagon that took her to South Chicago police headquarters, where she was booked.

Once the field had been cleared, officers combed the area for evidence. They amassed a trunk full of iron bars, wooden clubs, bottles, stones and other items—seventy in all—that could be used as weapons but found no firearms or shell casings other than those from police .38s. Everyone, police included, agreed that the prairie had been littered with all manner of trash for as long as neighbors could remember and that it was virtually impossible to distinguish between items that had been laying there and any discarded by marchers. Robert Fleming said the searchers gathered up about twenty sticks he used to support tomato plants in his garden. He noted that they also scooped up a milk bottle he used for watering. His teenage neighbor, George Jolly Jr., testified that the police collected about twenty rocks and some junk that he'd dumped the week before. Jolly said he used to "go junking" in the prairie and find "little pieces of iron, bolts, nuts of various kinds," but Captain Mooney produced a more incriminating discovery not likely

Various items of discarded junk still litter the ground east of the plant site as they did in 1937. *Photo by John F. Hogan.*

dumped by a litterbug—a two-by-four with a razor blade imbedded in it. A woman who was near Lupe Marshall as she was being arrested lost her shoe. Fleming found it and returned it to her when she came back looking for it.

After the last of the marchers had retreated or been hauled away to the hospital, morgue or lockup, after the police had completed their search of the field, the pickets outside the Republic plant continued their slow, steady shuffle, not bothering anyone, while the men who had been watching from inside went back to playing cards, reading the Sunday papers, making steel or whatever else they were doing.

CHAPTER 9
A LONG TIME COMING

\mathbf{F}earful that the strikers and their sympathizers might try to regroup and storm the Republic plant, John Prendergast, chief of the uniformed police, ordered nine hundred officers to guard the facility in three eight-hour shifts. The chief called for an additional two hundred–man force to assemble at the Hyde Park station, about ten miles north of the plant, and be prepared for immediate deployment. Prendergast needn't have worried. The sole visitor of note to the battlefield as of Tuesday, June 1, was SWOC regional director Van Bittner, who came armed only with a small concession he'd won at a five-hour meeting the night before. Illinois governor Henry Horner had arrived in Chicago from Springfield little more than an hour after the confrontation, but his hopes of mediating an end to the strike went glimmering. The governor met Sunday night and then again the following evening with Bittner, police and federal, other state and company officials whose sole accomplishment was an agreement that allowed strikers to picket in unlimited numbers as long as they remained peaceful and unarmed. At some point during the evening, Horner received a firsthand report from Captain Cartwright, who was ordered to personally convey his findings to the governor after first telephoning his superiors.

When Bittner made his visit to the plant, he found about sixty pickets on duty, up from only eight in the immediate aftermath of the battle. The SWOC leader grandiosely promised to steadily increase the number to one thousand. Later, he convened a meeting at Eagles Hall at which he read a telegram from Phil Murray, expressing shock "at the almost indescribable

horror." Murray pledged the moral and financial support of SWOC to bring the guilty to justice. "There is a growing feeling," he asserted, "that there is definite collusion between Chicago police and Republic Steel Corporation." The union leader's wire was sent from SWOC headquarters in Pittsburgh. He made no mention of plans to visit Chicago, and John L. Lewis wouldn't be heard from publicly on the strike for a couple of weeks. Bittner's own statement called the police action "in shooting down defenseless men, women and children...one of the most disgraceful affairs that has ever taken place in the history of our country." At this point, Bittner was being shadowed by Captain Cartwright, whose reports on the union leader's words and movements received such high priority that he was again ordered to personally brief the governor. Horner, in turn, told Cartwright to share his observations with Commissioner Allman or Chief Prendergast. One rumor that put the governor on edge had 125 truckloads of pickets bound for the Republic plant from Indiana Harbor. That rumor, not relayed by Cartwright, proved totally unfounded and appeared ridiculous on its face, but the seriousness with which it was treated illustrated the nervousness of state and local officials in the aftermath of Sunday's violence.

Mayor Kelly sided with the police. From his summer home at Eagle River, Wisconsin, where he'd spent the holiday, the mayor issued a statement attributing the violence to "outside mobs who came to Chicago to make trouble." He expressed confidence that "the well-disciplined police" would protect life and property.

While the words "mob, riot, outsiders and Communists" filled newspaper pages, another term was crossing the lips of steelworkers: "massacre." It's a powerful term, a judgmental, inflammatory term, so much so that even the La Follette subcommittee and the independent Citizens Joint Commission, which both condemned the conduct of the police, refrained from using it. The title page of each report employed the expression "Memorial Day Incident," and the word "massacre" wasn't used in the texts. That feelings of anger and disbelief permeated the rank and file goes without saying, but more nuanced emotions prevailed as well. George Patterson felt that the period immediately after the violence went by "in a complete daze." He wrote of Fontecchio holding the first regular SWOC staff meeting afterward "in the drab, dismal office of the East Chicago Bank Building. It was a subdued staff that met him. We looked at each other and the truth was in our eyes."

Tuesday, June 1, found Patterson downtown, trying to carry on union business as usual, dealing with a matter that had nothing to do with the

Republic strike. He mentioned stopping at Toffenetti's Restaurant with a *Tribune* to read during his meal. "The headlines were all about the riot at Republic Steel. Pictures of it were all over the pages. I looked at them, read the captions...looked around at the 'white collar' folks eating around me, and I, in my emotional state, wanted to scream, that the whole story of the riot was slanted to blame the steelworkers. That the police were shown to be blameless...Lies—all lies, I wanted to say. But there they sat, showing an indifference that shocked me. I came home sick at heart."

It was true: the steelworkers were taking a second beating at the hands of the press. Patterson had a right to be angry when he looked at a photo of two policemen, bracketed by four others, dragging a limp striker off the field by each arm. The caption read: "POLICE AID INJURED—With the rioters in retreat, the policemen carried the injured to ambulances to be taken to hospitals." There were no ambulances. Or a picture of Earl Handley, who bled to death after he'd been pulled from Archie Paterson's car and had his tourniquet yanked loose. "RIOTER WOUNDED IN THE LEG—Police carry rioter off the field after he has been struck in the right leg by a bullet or some sharp missl [*sic*]. He was given hospital treatment for his wound, a serious one." He was DOA. The *Tribune's* main story Monday began, "Steel strike rioters, attempting to invade the Republic Steel Corporation's plant in South Chicago, precipitated a bloody battle yesterday." If Patterson had turned to Tuesday's editorial page, he probably read that he and his friends were part of "a murderous mob...lusting for blood and defying police" who conducted themselves "with scrupulous correctness" to protect the lives of the men inside the plant." If the mob had had its way, the editorial concluded, "No one's life in Chicago and no one's property would be secure."

Some readers no doubt shrugged—or steamed—and thought, "Well, that's the *Trib* for you; the cops can do nothing wrong, unions can do nothing right." But the paper eventually found company on just about every other editorial page in town, though the others withheld judgment until the coroner's verdict came in. The *Daily News*, which prided itself on its independence and whose stringer became the La Follette subcommittee's star witness, editorially hoped for an end to attempts "to make Memorial Day martyrs of the rioters" who were "incited by ignorant or malicious leaders...duped—and exalted." The police, the editorial continued, "used firearms on an attacking mob which outnumbered them ten-to-one. ...What are they to do? Bow their heads? Submit?"

Mayor Kelly returned from his holiday getaway and assumed a slightly more conciliatory stance toward the union. First, he listened politely to a

delegation representing Carnegie-Illinois locals, which asked for the dismissal of Commissioner Allman and Captain Mooney. Later in the day, he ordered an investigation—not into the causes of the bloodshed, the conduct of the police, the treatment of the wounded or anything else pertinent. His Honor demanded to know whether or not Republic Steel was violating Health Department regulations by housing "loyal" employees inside the plant when they were off duty. The answer came back swiftly in the affirmative, so within a few days, Republic complied with an eviction order by moving twenty-one Pullman sleeping cars into its yards to accommodate more than one thousand men who remained inside. The rest would start coming and going at the beginning and end of their shifts as they would under normal conditions. Pickets made no attempt to block the Pullman cars when they were brought in.

On the eve of the public funeral for three of the slain demonstrators, Bittner went on the radio in Hammond to challenge the Little Steel companies to place the controversy before President Roosevelt. About the same time, Krzycki, whose oratory helped kick off the Memorial Day march, addressed 350 strikers at Croatian Hall, Ninety-fifth Street and Commercial Avenue, in South Chicago. "We are going to fight on to victory, regardless of the cost in lives of our martyrs," cried the man who spent the march at union headquarters. "If Republic was unwilling to meet the union halfway," Krzycki vowed, "we are ready to spill our blood in large quantities in the middle of the road."

The next day, some seven thousand mourners turned out at Eagles Hall to pay respects to three who already had spilled their blood—Alfred Causley, Sam Popovich and Joseph Rothmund. Fewer than one thousand could fit inside the hall where the men lay in state in open coffins prior to the eulogies. The remainder of the crowd stood outside and listened to remarks over loudspeakers by Bittner and Reverend William Waltmire, pastor of Humboldt Park Community Methodist Church. Bittner, the highest-ranking SWOC leader in attendance, denounced the police, whom he accused of "the wanton murder [of] defenseless pickets" at the bidding of Republic Steel. Seated behind him on the platform were Fontecchio, Krzycki and Weber.

Two days later, Weber, along with George Patterson, John Riffe and Gary SWOC organizer Mirco Pecovich, found themselves under arrest on orders of state's attorney Thomas Courtney. Riffe and Pecovich were released after a few hours, but Patterson and Weber were held overnight as police disclosed that they were searching for more ringleaders. Although the authorities said

Poster announcing funeral services for Joseph Rothmund, Alfred Causley and Sam Popovich. The number of mourners was estimated at seven thousand. *Courtesy of Local 1033, SOAR.*

they planned to charge the two in custody with some unspecified crime, no charges were brought and no further arrests were made at that time. It became apparent that the police and state's attorney's office were working the press to solidify their image while keeping the onus for the trouble on the strikers. The arrests of Weber and Patterson netted a dramatic but ultimately meaningless *Tribune* headline that read: "Two Held as Riot Leaders." The story featured photos of a knife with its handle jammed into a pop bottle and a razor blade inserted in the end of a club. A caption identified the makeshift weapons as being "taken from participants in riot at Republic Steel" when, in fact, no weapons were taken from anyone; all items identified by police as weapons supposedly were gathered from the battlefield. The city pointed to such handmade instruments as further evidence of a prearranged battle plan. If a few officers brandished axe-handled clubs, the explanation went, they were "wrestled from or discarded by members of the mob" after the policemen's own batons had been broken or knocked from their hands. Still another picture showed Weber behind bars. The shot was taken months earlier during the Fansteel strike in North Chicago. The following two days brought news reports bearing police department fingerprints of the "riot plot" that had strikers undergoing military-style drills in the days prior to Memorial Day.

On the other side, union supporters were by no means standing still. The night of June 8, a crowd estimated at 4,500 packed the Civic Opera House to protest police conduct. Among the organizers were future U.S. Supreme Court justice Arthur J. Goldberg, future U.S. senator Paul H. Douglas and future Chicago alderman Leon M. Des Pres. The attendees approved a resolution establishing a Citizens Joint Commission of Inquiry to investigate and report on the incident.

Douglas, a University of Chicago economics professor, was pursuing an objective that would produce the greatest insight into what happened at some of the most critical moments on Memorial Day. He began by formally requesting Paramount Pictures to release its newsreel footage. A Paramount official wired back that the film had been "shelved" because its contents were so "tense and nerve-racking" that their showing in crowded movie theaters could trigger "hysteria" and "riotous demonstrations" that would lead to further casualties. In withholding the film, the studio executive sanctimoniously declared that Paramount was placing sound public policy ahead of profits. He further defended his company's decision by claiming the pictures "were not fit to be seen" and were being withheld the way newspapers would refuse to print "news not fit to read." Paramount, in essence, was

waving a red cape in front of a civil libertarian. Douglas promptly appealed to the La Follette subcommittee to subpoena the film along with that taken by Reverend Fisk and impounded by the Chicago Police Department.

While Douglas awaited a response, John L. Lewis and Tom Girdler sounded off publicly. Lewis called on President Roosevelt and state governors to close all steel mills continuing to operate under strike conditions and keep them closed until their employees signed agreements with the CIO.

Girdler issued a statement from Cleveland in which he accused the CIO of tearing up railroad tracks, blocking mail trucks, beating up hundreds of men, defying local authorities by massing troops of armed pickets, stoning workmen's homes and shooting at airplanes."

The war of words appeared headed for an escalation, if that was possible, when Chicago-area union leaders mapped plans for Lewis to address a mass meeting the night of June 17 at the nearly seventeen-thousand-seat Chicago Stadium on the city's Near West Side. The speech was to be preceded by a car caravan that would start in Indiana Harbor, pass the Inland, Youngstown and Republic/South Chicago plants and conclude at the stadium. The motorcade went forward, and some twelve thousand strikers and their supporters turned out for the meeting, but Lewis did not. He sent a telegram from Washington citing "imperative circumstances" that prevented his attendance. Lewis didn't explain, but his regrets coincided with an announcement that Secretary of Labor Frances Perkins had appointed a board of conciliation to make recommendations for settling the strike. In his telegram, which was read to the assemblage, Lewis charged that those killed on Memorial Day "were deliberately murdered by the Chicago police as a friendly favor to the Republic Steel Company." He expressed confidence that the "butchery" would be avenged by the judicial process.

Four days later, the CIO leader resumed full voice. In words aimed at President Roosevelt, Lewis cried out, "Somewhere in this nation should be a force strong enough to bring these uniformed killers and their co-conspirators to justice...Is labor to be protected or is it to be butchered?" At a news conference a week later, the president rose to the bait. Perhaps frustrated that Secretary Perkins's mediation board had been unable to settle the strike, Roosevelt invoked a quotation from Shakespeare: "The majority of the people are saying just one thing, 'A plague on both your houses.'" Presidential aides hastened to explain that the chief executive was referring to extremists on both sides, but as far as the CIO was concerned, the damage had been done. Lewis managed to contain most of his rage when he responded sarcastically, "Which house, Hearst or Du Pont?" But

practical politician FDR was following the counsel of his advisers; nothing he could say or do would alter the fact that the strike had been lost. Most Little Steel plants were on their way back to normal. Republic said its South Chicago mill was running at 85 percent capacity.

Away from the supercharged rhetoric, events were moving swiftly. Five staff members of the La Follette subcommittee, under the direction of Secretary Robert Wohlforth and Counsel John Abt, quietly arrived in Chicago to begin ten days of interviews and records examinations. (The assignment would be one of Abt's last. In a move to rid his staff of Communist influence, La Follette soon afterward dismissed Abt, Investigator Kramer and several others.) Their arrival occurred the same day the coroner's jury held its second pro-forma session, the first coming the day after Memorial Day. Early in their investigation, the Senate staffers accompanied Captains Mooney and Kilroy on an inspection tour of the battle scene and listened to their version of events. The investigators also looked into a mass of affidavits and received copies of the film taken by Reverends Fisk and Sanford, which were provided by the state's attorney's office. State's Attorney Courtney balked at a request for official statements by police officers and members of the crowd, saying he first needed to complete his own investigation.

La Follette biographer Patrick J. Maney maintained that the senator practically had to be strong-armed into investigating the Chicago violence. A couple weeks beforehand, La Follette was about ready to permanently adjourn the subcommittee, believing it had accomplished all it could. Even after viewing the Paramount film and finding the events "unfortunate," La Follette was reluctant to become involved. Only after several days of intense prodding by his staff did he agree to go forward.

All of a sudden, *three* official bodies were looking into the matter. The Senate Post Office Committee jumped in to investigate allegations that postal authorities were bowing to CIO pressure and withholding deliveries of food and clothing to Republic's marooned Youngstown, Ohio employees. Pro-business and pro-labor senators jousted over the definition of U.S. mail and the right of postal workers to refuse to make deliveries in unsafe conditions. The committee's stated purpose got relegated to the background when labor-friendly senators turned the spotlight on the violence in Chicago. Republicans complained that that was their opponents' intent from the outset, and in this context, they were said to enjoy support from an unlikely source, Senator La Follette, who held his tongue publicly but plainly did not appreciate colleagues poaching in a field—violations of the rights of labor—that had been his panel's

domain for the past year. Memorial Day in South Chicago was threatening to become a political football.

For the near term at least, La Follette left the grandstanding to the other committee; he had more productive work to do. The Post Office Committee called Phil Murray, who lost no time in accusing the Chicago police of "cold-blooded and deliberate murder" and being "notoriously corrupt and in complete alliance with the steel corporation." Murray read into the record a description of the Paramount newsreel film that the *St. Louis Post Dispatch*, in a copyrighted story, had published in full graphic detail that day. The description of events shown in the film, the paper said, "comes from a person who saw it several times and had a particular interest in studying it closely for detail," obviously the chairman or someone acting with his acquiescence if not direction. La Follette, his fellow subcommittee member Elbert Thomas, Democrat of Utah, and their staff had screened the footage in secret after Wohlforth obtained a copy under the table from a friend at Paramount. (A third member of the senate panel died shortly after its formation and was not replaced.) Whether the subcommittee acted at the urging of Chicago's Paul Douglas wasn't clear. After the Post Office Committee heard Murray's reference to the suppressed film, it voted to subpoena the footage from its Senate colleagues.

Paramount still refused to release the film to the public, but a significant crack had appeared in its defenses. The universal perception of what transpired on May 30, 1937, would never be the same. Humans may describe events one way or another, but the camera, as someone said, doesn't lie.

Until the *Post-Dispatch* report was reprinted by papers all over the country, the police account of events had dominated news coverage. Greatly outnumbered officers were described as fighting for their lives against a mob of rioters determined to invade the plant and do great bodily harm to those inside. It would take a while before the newsreel footage became public, but in the meantime, the lengthy *Post-Dispatch* story offered a careful, accurate account of the film's contents.

Those who saw it were shocked and amazed by scenes showing uniformed policemen firing their revolvers point-blank into a dense crowd of men, women and children and then pursuing and clubbing the survivors unmercifully as they made frantic efforts to escape...In a manner which is appallingly businesslike, groups of policemen close in on these isolated individuals and go to work on them with their clubs. In several instances, from two to four policemen are seen beating one man. One strikes him

horizontally across the face, using his club as he would a baseball bat.
Another lashes it down on top of his head and still another is whipping
him across the back.

Senator Thomas, a genial former college professor, said the film showed "extreme brutality" and expressed surprise that the number of casualties wasn't far greater.

Doubters remained. The *Tribune* scoffed that the *Post-Dispatch* story "gave the impression that the CIO rioters were merely seeking to march past the Republic plant with all the innocence of a Sunday school picnic parade, and that they were fired upon from ambush, without warning and without provocation, by the 'brutal policemen.'" Two days later, as Captains Mooney and Kilroy prepared to leave for Washington to testify before the Post Office Committee, the *Tribune* followed up with a supportive spread citing the accounts of those two, Chief Prendergast and no fewer than seventeen officers who were involved in the mêlée. The extensive piece had to involve the full cooperation if not the instigation of the department at a time when the state's attorney was withholding police statements from the La Follette panel on the grounds that they might prejudice cases against march instigators. All the accounts of mysterious gunmen, shots from the crowd, life and death struggles, women with barbed-wire clubs and razor blades and more were on full display, descriptions of what the film showed notwithstanding. That night, outside Youngstown, Ohio, one striking steelworker was shot to death and a dozen persons injured as police and strikers fought a three-hour battle at the shuttered Republic plant.

When Mooney appeared before the Post Office Committee on June 24, he reiterated that his officers were forced to shoot to save their own lives. "I didn't give any order to fire," he asserted, "but the men who got hit with brickbats and automobile parts defended themselves. If ten of them were killed it's too bad, but there would have been two hundred killed if they had ever got through to that plant." Mooney added that members of the advancing throng weren't steel strikers but outside agitators, "brought there by the Communists" and who sang the "Communist *Internationale*." The committee also heard that day from Tom Girdler, at the top (or bottom) of his game, denouncing the CIO as "irresponsible, racketeering, violent and communistic" and posing "the most dangerous threat" to American democracy.

Mooney and Kilroy enjoyed a cakewalk before that group of senators compared with their reception six days later on the first day of the La Follette

subcommittee's public hearings. "Chicago's finest" did not experience their finest hour. In addition to the two captains, the subcommittee would hear from six other members of the department—one sergeant and five patrolmen. Under cross-examination, the stories of three officers—Higgins, Igoe and Jacob Woods—fell apart, contradicted by their earlier testimony, photographic evidence or both. Describing just one of his many adventures (or misadventures), Higgins went on to some length about how Sergeant Oakes shot Joe Rothmund ("the lousy Communist") in the stomach during a struggle in which Rothmund held a nickel-plated revolver that was never found and died of a bullet wound in the middle of the lower back. Igoe's testimony that he was attacked and beaten to the ground by a group of strikers was clearly contradicted by photos showing no marchers within twenty feet of his position and all policemen on their feet at the time and place the alleged attack occurred. Woods's testimony produced a host of discrepancies between his affidavit and a separate statement he made to the department. For example, he testified that a striker had threatened him with a meat hook, a dramatic experience that he somehow failed to mention in his affidavit. He did mention that he heard a gunshot from within the crowd that sent a bullet into the door of a patrol wagon parked about two feet away from him. Under cross-examination, Woods admitted that he didn't know whether the wagon door had been hit by a bullet or whether there had been any shots from the crowd.

Further improbable testimony came from Sergeant Lawrence Lyons. La Follette showed Lyons a photo of the crowd in full retreat with a policeman, right arm outstretched toward the marchers, at the far left of the frame. The senator had Lyons look at the picture through a magnifying glass and identify what he saw in the officer's hand. The sergeant said it looked like a rock. Before La Follette could question the likelihood of a policeman pointing a rock at a crowd, Lyons changed his opinion. It must be a smudge in the photograph, he said. Another photo showed an officer reaching for his holster.

"What is he doing with his right hand?" asked Senator Thomas.

"He may be drawing a handkerchief," the sergeant replied.

"Out of his holster?"

In one of the most dramatic confrontations, Senator La Follette showed Captain Kilroy a photo of several policemen clubbing two marchers on the ground and offering no resistance while Kilroy stood idly by.

"Is that policeman using his club in self-defense?" the senator asked.

"No," Kilroy replied.

THE 1937 CHICAGO STEEL STRIKE

Senator Robert M. La Follette Jr. looks on as fellow subcommittee member Senator Elbert Thomas points to a photo of police pursuing strike demonstrators. *Courtesy of the Chicago History Museum 1CH-68127.*

"Does that meet with your approval?"
"No."
"Do you justify such conduct?" La Follette demanded.
Kilroy did not reply.
"Are you ashamed of it?"
No response.
"Isn't that a pretty brutal thing?"
"It is," the captain replied in a low voice.
On July 2, the final day of the hearings, some seven hundred spectators in the committee room, along with moviegoers in most of the country, got an opportunity to see the Paramount newsreel footage. In releasing the film, a movie company executive pointed out that more than a month had elapsed, adding questionably that "conditions have changed for the better and the feelings of yesterday have subsided." A *New York Times* reporter who visited the Paramount Theater in Times Square wrote, "When the police charged into the milling crowd of strikers, dispersing them with tear

gas bombs, revolvers, and night sticks, the audience gave a collective gasp and then watched in silence as the camera unfolded further details of the battle." Chicago moviegoers would have to wait or go elsewhere to see for themselves. The police department's chief movie censor, Lieutenant Harry Costello, announced that the film would not be shown in the city's theaters because it was unfit for public viewing.

Preliminaries dispensed with, the Cook County coroner's inquest reopened on July 14, while back in Washington, staff members of the La Follette subcommittee set about reviewing the testimony of thirty-three witnesses and poring over other evidence compiled during their investigation. In Chicago, an opening statement by first assistant state's attorney Wilbert Crowley (later chief justice of the Cook County Criminal Court) signaled that the police were back in friendly territory, the local Criminal Court Building, not that they needed any reminder. "We will track down those responsible for this riot and punish them to the full extent of the law," Crowley vowed. "I am particularly concerned as to who spoke at the meeting which preceded the riot and what those speakers said." He suggested that his office might seek conspiracy to commit murder charges against Weber, Fontecchio and Krzycki.

The day's final witness, Louis Selinek, offered the most noteworthy observation when he agreed that the marchers intended to get through to the Republic plant using camouflaged picket banners as clubs to smash through the police lines. Other witnesses repeated familiar details of the mêlée. Captain Mooney told the jury that the barrage of bricks thrown from the crowd represented "a regular Communist tactic…intended to break police lines and throw them into confusion."

On the third day of the resumed inquest, the coroner's jury got a look at the Paramount newsfilm, which was shown in a screening room at the company's studios, 1306 South Michigan Avenue, just south of downtown, following the morning session at the courthouse. In the opinion of cameraman Orlando Lippert, "The riot undoubtedly was caused by the rocks and other missiles thrown into the police lines by the strikers." Lippert shed some light on the seven seconds that elapsed while he was changing lenses. At the same time he saw stones flying, "a group of strikers in the rear pushed those in front into the police lines. That's the part of the film that's missing." As he was about to leave the witness chair, Lippert offered a final recollection. "During the excitement, I dropped an extra lens. I felt someone tap me on the leg. I looked down to see a policeman with a bloody face. He had picked up the lens to hand it to me."

Earlier in the day, Coroner Frank Walsh had attempted to soften the testimony of Dr. Jacques, who told the La Follette subcommittee that seven of the ten men killed had been shot in the back. After a bit of semantic skirmishing, Dr. Jacques conceded that some had been shot "more toward the back than the front."

By the fourth day of proceedings, the jury still had not heard from any of the policemen who admitted firing their weapons, a delay that was drawing increasingly loud complaints from CIO attorneys. Finally, on July 19, three officers testified that they shot in self-defense. Sergeant Walter Oakes, identified by fellow officer George Higgins as the one who fatally shot Joe Rothmund, told his account for the first time in an open forum. Unlike Higgins, Oakes didn't testify before the La Follette panel. He said he was clubbed to the ground and kicked by more than one man. After Higgins dropped one of the attackers with a punch, he related, he saw another man standing over him with his foot raised, "ready to bring it down on some part of my body. I rolled over. I had nothing with which to protect myself but my gun. I believed my life was in danger. I fired five shots upward at the man...He fell backward." Oakes said he was unable to identify the man or say whether he was killed, even though his testimony came weeks after Higgins described his fellow officer "perforating the lousy Communist in the stomach" and after the autopsy disclosed that Rothmund had died of a bullet wound to the center of the back. Significantly, Oakes failed to repeat Higgins's allegation that his attacker was armed with a nickel-plated revolver.

Officers Lloyd Casey and Joseph Hooley essentially repeated the accounts they gave a month earlier to the *Tribune*. Casey told of shooting and dropping a man coming at him with a meat hook and scaring off two companions by firing twice in the air. Hooley testified that he fired once at a man who had knocked his nightstick from his hand with a club then threatened to "beat his brains out" if he didn't step aside. When a CIO lawyer tried to draw him into a discussion of what constituted peaceful picketing, Hooley replied testily, "Some fellow bounced a club off my head. I suppose he was out on a Sunday school picnic."

"From the testimony presented, we believe this occurrence to be justifiable homicide." With those words, the coroner's jury absolved the Chicago police of any wrongdoing in the deaths of ten men fatally shot outside the Republic Steel plant on Memorial Day 1937. Instead, the jury placed responsibility on an armed mob marching with the apparent intention of breaking through police lines and invading the plant. The central wording of each of the ten verdicts was virtually identical. For example: "We find that Kenneth Reed came to his death on the 30th day of May in the Burnside Hospital from

a bullet wound of the abdomen, caused when the deceased was struck by a bullet fired from a gun held by an unknown police officer during a riot, started when a large body of strikers and strike sympathizers, numbering approximately 1,500 to 2,000 persons, many of whom were carrying clubs and missls [*sic*], attempted to force their way through a police line, apparently to enter the plant of the Republic Steel corporation in South Chicago, Ill." In the death of Alfred Causley, the only one of the ten shot multiple times, according to the coroner, the words bullet, gun and officer became pluralized. Left unchanged in the Rothmund case was the term "unknown police officer," when the testimony of Sergeant Oakes to the jury and that of Patrolman Higgins before the La Follette subcommittee clearly pointed to Oakes as the shooter.

Coroner Walsh proclaimed the verdict full and fair and said every effort was made to call impartial witnesses. He took a swipe at the La Follette hearings for allegedly badgering police witnesses and turning the proceedings into a CIO forum. Assistant state's attorney Mal Coghlan, who presented the state's case, went further in criticizing the labor group. He said testimony showed that "CIO leaders supervised the arming of the mob and planned and incited a violent attack upon the police." He stated that workers who have a right to strike "were misled by insane leadership, resulting in tragedy."

The *Tribune* editorial page picked up where Walsh and Coghlan left off. The paper blasted "Senator La Follette's curious committee" for conducting "an entirely prejudiced investigation" that gave the country a false impression of what occurred. Shots of marchers attacking the police were not part of the Paramount newsreel, the editorial pointed out, creating the overall impression the officers were brutally assaulting "innocent, law-abiding people…without any excuse." Testimony at the coroner's inquest revealed the truth, the *Tribune* concluded.

Chicago police and their defenders had only two days in which to savor the coroner's jury verdict. On July 22, the La Follette subcommittee released its report of investigation. No matter how many times one reviews the separate sets of findings, it's hard to believe that two official bodies could review the same evidence, look at the same photographs and newsreel footage, question many of the same individuals and reach such startlingly different conclusions. The senate panel presented four overarching points:

- The strikers had the right to picket the plant in unlimited numbers as long as they remained peaceful. Captain Mooney acted arbitrarily in blocking the march and did so without legal authority and without

consulting Commissioner Allman. "If the police had permitted the parade to pass down Burley Avenue and in front of the plant gate, under a proper escort, the day would have passed without violence or disorder."

- The police were ill-prepared to handle the demonstration. There was no "real consideration" of the tactics to be employed, and no preparations were made for the use of tear gas. "The whole police detail was sent to the prairie with the most perfunctory instructions, if any."

- The police used much more force than necessary to disperse the crowd. Tear gas should have proved sufficient, "but guns followed almost instantaneously." The only provocation of the police came in the form of abusive language and "the throwing of isolated missiles."

- The consequences of Memorial Day were "clearly avoidable by the police."

Without mentioning the names of individuals or agencies, the list of conclusions ended with a slam against the City of Chicago, its police department, the state's attorney, the coroner and the coroner's jury: "The action of the responsible authorities in setting the seal of their approval upon the conduct of the police not only fails to place responsibility where [it] properly belongs but will invite a repetition of similar incidents in the future."

Senator Thomas added a one-page statement in which he agreed that "the encounter of May 30 should never have occurred." Then he added, "those who died were not martyrs to a cause. They were victims of circumstances, lack of sound judgment and inexpedient actions."

Back in Chicago, the "responsible authorities" cried foul. Assistant corporation counsel William V. Daly, who represented the City at the La Follette hearings, charged that the subcommittee hurried its report in an attempt to favor the sixty-four defendants facing prosecution for their roles in the disorder. Daly objected further that the report was issued before the City had an opportunity to submit the additional evidence that the subcommittee had requested (statements of various officers and civilians, including that of Jean Carleton Carey, the student who told of seeing strikers with guns and other weapons). Mayor Kelly coupled a defense of the police with the observation that attorneys for the strikers were allowed to cross-examine witnesses at the coroner's inquest while the same opportunity was denied the City at the Washington hearings. "The police were attacked," the mayor

noted. "There was no general order to shoot. Any man's natural instinct is to protect himself when he is on the ground.

Controversy over National Guard captain Cartwright's report surfaced on July 9 when General Keehn, commander of the Guard, wrote to Illinois' U.S. senators, James Hamilton Lewis and William H. Dietrich, in an apparent attempt to deter Senator La Follette from going public with the document. Keehn noted that the City "is especially desirous" of obtaining the report, a development that obviously concerned him. The general sent the senators background information, as well as a copy of the Guard's Emergency Plan for Domestic Disturbances, but the submittal contained a caution. "If these reports and photos are to become public property, it will undoubtedly interfere with if not completely destroy any further use of the Plan," General Keehn wrote. The Guard commander asked Lewis and Dietrich to treat the report as confidential. Use the information as you deem appropriate, he advised, "so long as investigators and the National Guard are kept out of the picture." According to Illinois National Guard historian Adriana Schroeder, General Keehn didn't want to convey the erroneous impression that the Guard routinely spied on the activities of labor unions or other groups.

Two weeks later, Daly sent a letter to Senator Lewis, asking that he and Senator Dietrich present Captain Cartwright's evidence, which Daly claimed to have, to the La Follette subcommittee or the full senate "in such a manner that the source...will not be revealed to the general public." Daly stated that military effectiveness would be seriously impeded if the source of the information became known by "men who are engaged in subversive activities against the government." La Follette disregarded the pleas and made the Cartwright report part of the subcommittee's official record in late August. The captain's identity remained secret, but General C.E. Black, the Guard's deputy commander, still was displeased that the City had gotten its hands on the report in the first place. He assigned the captain to discover how this breach had happened, but despite two follow-up inquiries by General Black, Guard records fail to divulge an answer. We're left to guess why the general believed that such a document in the possession of a congressional office would remain confidential for long.

The controversy had all but subsided by August 31 when the independent Citizens Joint Commission issued its report. The fourteen-page document amounted to a virtual summary of the La Follette report except for its recommendation that all who "had any responsibility for the disgraceful episode" be subject to discipline and censure. Commissioner Allman, Chief

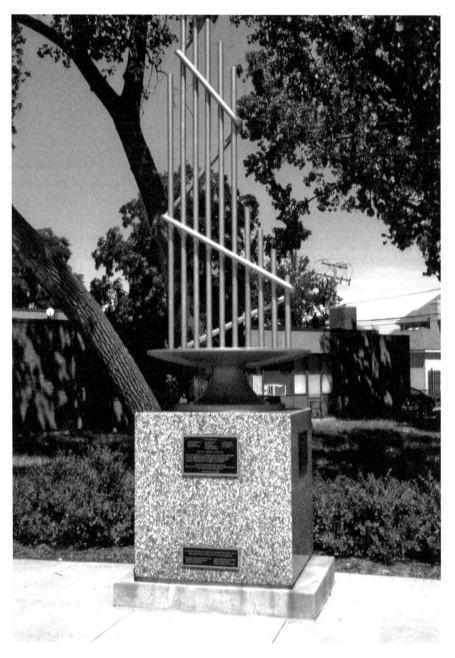

Memorial to slain strikers on the northeast corner of 117th Street and Avenue O, immediately north of union headquarters. Chicago Fire Department Engine Company 104 and Truck 61 occupy the building to the far left. *Photo by John F. Hogan.*

Prendergast and Officer Higgins were singled out. The group saved its harshest criticism for Captain Mooney, whom it said should be relieved of his duties. According to the *New York Times*, the report "apparently failed to stir a ripple in either citizen or police circles." City hall and the police department called it a "dud."

A couple weeks later, AFL president Green weighed in belatedly by blaming the loss of the strike and the attendant bloodshed on John L. Lewis and said no "sophistry" or "scurrilous denunciation" could shift the blame "from the shoulders of those who were directly responsible." Green claimed that an "overwhelming majority" of steelworkers opposed the strike but weren't given an opportunity to vote beforehand.

With scant attention, conspiracy charges against sixty-four persons got continued and finally dropped. On December 20, 1937, fifty-four defendants pleaded guilty to charges of unlawful assembly before Judge Joseph A. Graber of Chicago Municipal Court. The group included one woman, Ada Leder, the pregnant marcher who got clubbed across the backside. The judge levied fines of one dollar plus another dollar in court costs for those employed by the steel industry in the Calumet region, ten dollars plus two for all others. Judge Graber acted in accordance with the recommendation of assistant state's attorney Coghlan. In passing sentence, the judge said,

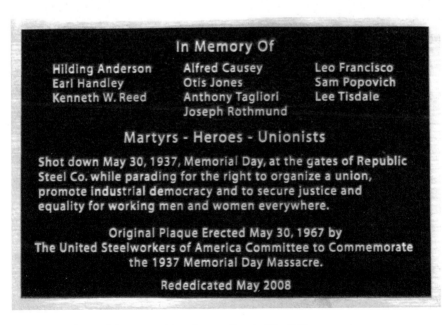

Plaque at the base of the memorial sculpture. *Photo by John F. Hogan.*

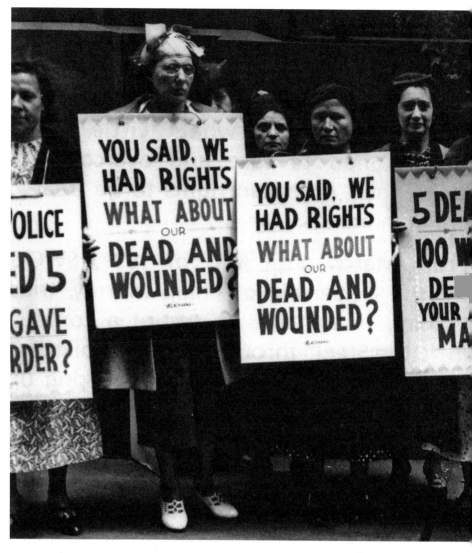

Women gather to protest the shootings and beatings before the death toll rose to ten. The last victim succumbed three weeks after being shot. *Courtesy of Local 1033, SOAR.*

"Those individuals are misled by agitators and people whose program is very, very vicious and causes a great deal of untold hardship…Mayor Kelly did the thing that his oath of office required him to do…I know [the police] were only activated by one thing and that was to do their duty." None of the officers was ever charged with a crime.

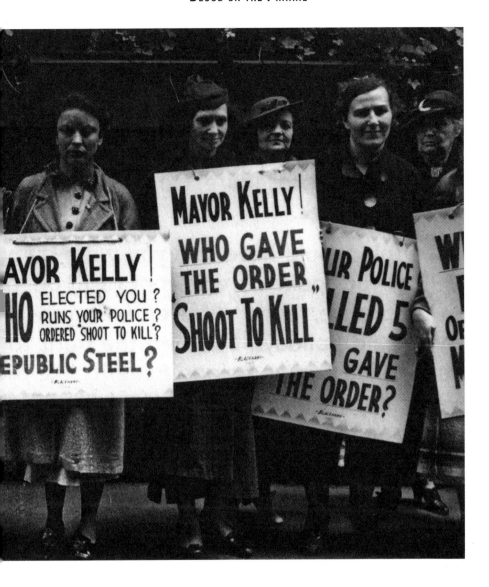

With the bloody year 1937 in the history books, the battle between Republic Steel and the CIO moved on to the NLRB and the courts. In these arenas, the union proved victorious. The labor board ruled in April 1938 that Republic had violated the Wagner Act eight times during the strike at various plant locations. The counts included acts of espionage and vilification against SWOC, incitement of violence in order to terrorize the union and responsibility for a battle in front of the CIO's Massillon, Ohio headquarters in which three men were fatally shot by the police. Republic was ordered

to reinstate five thousand strikers with pay going forward. Twenty-seven additional employees, discharged before the strike for union activity, were ordered restored with back pay that totaled just under $500,000. Republic also paid those injured by the violence and the families of those killed a total of $350,000. The NLRB decision was upheld by a federal district court and the U.S. Supreme Court, which refused to hear the company's appeal. Republic struck back in May 1938 by filing a $7.5 million damage suit against the CIO, SWOC, John L. Lewis and a number of other defendants. The company claimed it lost $2.5 million as a result of the strike and was entitled to triple damages. A federal district court in Cleveland dismissed the suit in June 1941, and Republic declined to appeal, setting the stage for the final act.

Tom Girdler was spared the fate of having to grow apples and potatoes because John L. Lewis was on his way out as head of the CIO. Lewis's rift with President Roosevelt had festered into open opposition by 1940 and was capped by the labor boss's return to his roots. Lewis endorsed Wendell Wilkie for president, promising to resign if the Republican failed to win. Soon after FDR handily dispatched his challenger in November, Lewis kept his word. Spouting poetry; paraphrasing Shakespeare and the Gettysburg Address; denouncing Communism, Nazism and the press; mocking Bill Green and the AFL; and full of his typical pomposity, John L. Lewis departed the stage, literally and figuratively, at the CIO convention in Atlantic City. His anointed successor, who else but Phil Murray, was unanimously elected president. Murray sought to assure the delegates that he would be his own man, no longer second banana to Lewis, but he sounded more like the Tin Man or the Scarecrow. "I think I have convictions, I think I have a soul and a heart and a mind..."

Girdler described the falling out between Lewis and Roosevelt and Lewis and his former CIO associates as "the most ironic development in the years since Republic Steel Corporation was being pilloried...Nothing I ever said about Lewis approaches in bitterness the denunciations of him that have since poured out of the mouths of the very people who denounced me in 1937 for refusing to sign a contract with this man."

The steelworkers' union may have lost the 1937 strike but ultimately won the labor war through sheer doggedness. The union kept adding Republic employees well into 1941, until the NLRB certified that it had signed up a majority. That reality, plus a fresh Supreme Court decision that said union agreements must take the form of written contracts, convinced Republic that, like it or not, a new day had arrived. On July 15, 1941, the company

publicly agreed to sign a contract with the Steel Workers Organizing Committee. The announcement was made by the NLRB in Washington and Tom Girdler in Cleveland.

Quiet, behind-the-scenes negotiations on a final agreement lasted more than a year. On August 11, 1942, a contract was ratified in Pittsburgh. It was a long time coming. J.W. Voss, Republic's director of industrial relations, was the company's lone signer. Phil Murray and more than twenty others signed for SWOC. Missing from the signature list were the names Tom M. Girdler and John L. Lewis.

BIBLIOGRAPHY

Adelman, William. *The Memorial Day Massacre of 1937.* Chicago: Illinois Labor History Society, 1973.

Alinsky, Saul. *John L. Lewis: An Unauthorized Biography.* New York: G.P. Putnam's Sons, 1949.

Auerbach, Jerold S. *Labor and Liberty: The La Follette Committee and the New Deal.* Indianapolis: Bobbs-Merrill Company, Inc., 1966.

Bork, William Hal. "The Memorial Day 'Massacre' of 1937 and Its Significance in the Unionization of the Republic Steel Corporation." Urbana, IL: master's thesis courtesy of the Chicago History Museum, 1975.

Citizens Joint Commission of Inquiry. *South Chicago Memorial Day Incident.* Chicago: self-published, 1937.

Doan, Edward N. *The La Follettes and the Wisconsin Idea.* New York: Rinehart & Company, Inc., 1947.

Dollinger, Genora (Johnson), with Susan Rosenthal. *Striking Flint.* Chicago: L.J. Page Publications, 1996.

Dubofsky, Melvin, and Warren Van Tine. *John L. Lewis: A Biography.* New York: Quadrangle/New York Times Book Company, 1977.

Girdler, Tom M. *Boot Straps.* New York: Charles Scribner's Sons, 1943.

Kampelman, Max M. *The Communist Party vs. the CIO: A Study in Power Politics.* New York: F.A. Praeger, 1957.

Kraus, Henry. *The Many and the Few: A Chronicle of the Dynamic Auto Workers.* Urbana: University of Illinois Press, 1985.

Levenstein, Harvey A. *Communism, Anticommunism, and the CIO.* Westport, CT: Greenwood Press, 1981.

Madison, Charles A. *American Labor Leaders.* New York: Frederick Ungar Publishing Company, 1950.

Maney, Patrick J. *"Young Bob" La Follette: A Biography of Robert M. La Follette, Jr., 1895–1953.* Columbia: University of Missouri Press, 1978.

Patterson, George A. "Autobiography." Unpublished ms., courtesy of the Chicago History Museum, 1982.

Roberts, Ron E. *John L. Lewis: Hard Labor and Wild Justice.* Dubuque, IA: Kendall/Hunt, 1994.

Selvin, David F. *The Thundering Voice of John L. Lewis.* New York: Lowthrop, Lee and Shepard Company, 1969.

Senate Committee on Education and Labor. *The Chicago Memorial Day Incident.* Washington, D.C.: United States Government Printing Office, 1937.

Steel Workers Organization of Active Retirees. *The Memorial Day Massacre, 70th Anniversary, The Fight Goes On.* Chicago: self-published, 2007.

Sweeney, Vincent D. *The United Steel Workers of America: The First Ten Years.* Pittsburgh: USWA, 1947.

BIBLIOGRAPHY

Taft, Philip. *Organized Labor in American History.* New York: Harper & Row, 1964.

United Steel Workers of America. *Remember Memorial Day May 30, 1937.* Chicago: self-published, 1979.

United Steel Workers of America Local 1033. *This Is Your Union.* Chicago: self-published, 1971.

Wechsler, James A. *Labor Baron: A Portrait of John L. Lewis.* New York: William Morrow and Company, 1944.

INDEX

M

machine guns 25, 26, 29, 38, 108
Madison, Charles A. 59
Maney, Patrick J. 128
Marshall, Lupe 90, 110, 116, 119
Massillon, Ohio 62, 141
May 30, 1937 9, 83, 129
McCulloch, Frank W. 85, 86
Meier, Governor Julius 30
Memorial Day 9, 11, 62, 76, 78, 81,
 86, 87, 122, 123, 124, 126, 127,
 128, 129, 134, 136, 145
Michael Reese Hospital 115
Mitckess, Ben 74
Mooney, James 63, 64, 67, 68, 69, 71,
 72, 77, 79, 88, 91, 92, 95, 96,
 98, 99, 101, 110, 115, 118, 124,
 128, 130, 133, 135, 139
Moran, Bart 95, 101, 102
Murphy, Governor Frank 48, 49
Murray, Philip 10, 21, 35, 36, 54, 55,
 56, 59, 61, 70, 121, 122, 129,
 142, 143

N

Napoli, Alexander 77
National Guard 24, 27, 29, 30, 48, 49,
 50, 86, 88, 90, 137
National Labor Relations Board
 (NLRB) 30, 60, 141, 142
National Longshoremen's Board 31
Newberry Library 10
New Deal 23, 40, 52
New York Times 26, 28, 59, 70, 74,
 132, 139

O

Oakes, Walter 108, 109, 110, 131, 134,
 135
Oliver Iron & Steel Company,
 Pittsburgh 14, 15
O'Neill, Francis 64
open shop 17

Opfer, Edward 74
Organized Labor in American History 76
Owens, Carla 11

P

Panama, Illinois 19
Paramount 92, 100, 126, 128, 129,
 132, 133, 135
Paterson, Archie 110, 111, 123
Patterson, George 56, 67, 69, 73, 74,
 77, 86, 87, 88, 90, 99, 103, 107,
 110, 111, 122, 123, 124, 126
Pennsylvania Railroad 68, 81
Popovich, Sam 111, 124
Portland, Oregon 24, 30, 31, 33
Prendergast, John 62, 77, 121, 122,
 130, 139
President Hotel, Atlantic City 34
Pressman, Lee 40, 54, 55
Progressive Party of Wisconsin 37
Pulsis, John 101

R

Reed, Kenneth 112, 134
Republic's Berger Manufacturing
 Division 33
Republic Steel Corporation 9, 10, 13,
 16, 17, 24, 26, 33, 36, 38, 39,
 46, 48, 53, 54, 57, 59, 60, 61,
 62, 63, 64, 65, 66, 69, 70, 71,
 72, 73, 74, 76, 77, 78, 81, 83,
 85, 86, 89, 90, 93, 95, 108, 111,
 116, 119, 121, 122, 123, 124,
 126, 127, 128, 130, 133, 134,
 141, 142, 143
Republic Steel, South Chicago plant
 9, 24
Reuther, Roy 40
Reuther, Walter 10, 24, 64
Revoir, Harold 88, 89
Rice, John 9
Richardson, E.E. 27
Riffe, John 61, 66, 67, 68, 69, 70, 71,
 76, 77, 90, 124

Y

ABOUT THE AUTHOR

Author of *Fire Strikes the Chicago Stock Yards: A History of Flame and Folly in the Jungle* with The History Press, Chicago native John Hogan is a published historian and former broadcast journalist and on-air reporter (WGN-TV/Radio). He has written and produced newscasts and documentaries specializing in politics, government, the courts and the environment. As WGN-TV's environmental editor, he became the first recipient of the United States Environmental Protection Agency's Environmental Quality Award. His work has also been honored by the Associated Press. Hogan left broadcasting to become director of media relations and employee communications for Commonwealth Edison Company, one of the nation's largest electric utilities. Hogan is the author of Edison's one-hundred-year history, *A Spirit Capable*. He holds a BS in journalism communications from the University of Illinois at Urbana–Champaign and presently works as a freelance writer and public relations consultant.